Painting Water

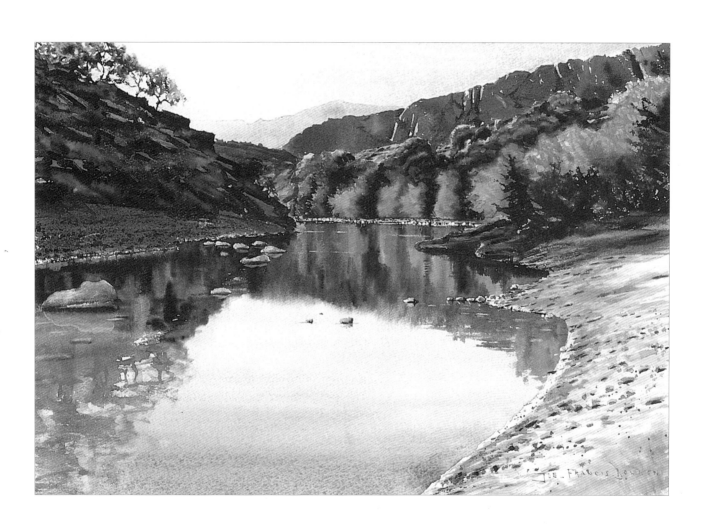

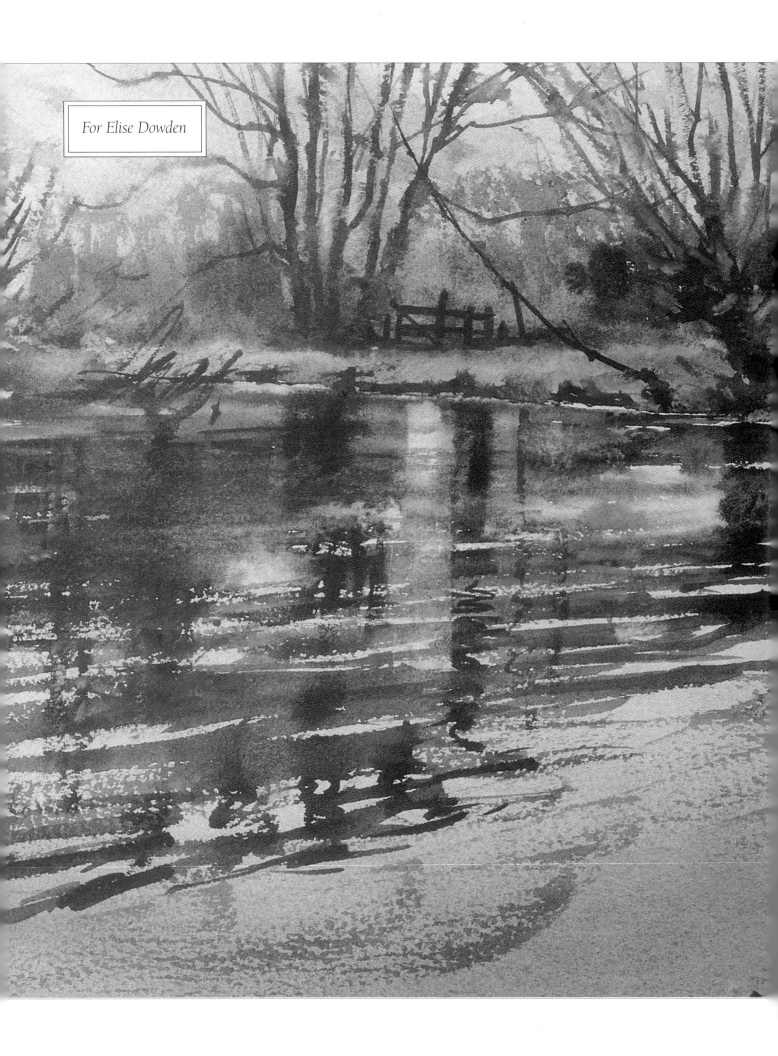

For Elise Dowden

Painting
Water

Joe Francis Dowden

SEARCH PRESS

First published in Great Britain 2003

Search Press Limited
Wellwood, North Farm Road,
Tunbridge Wells, Kent TN2 3DR

Reprinted 2005 (twice), 2006, 2007, 2008

Text copyright © Joe Francis Dowden 2003

Photographs by Charlotte de la Bédoyère, © Search Press
Studios, except the following:
pages 2–3, 7, 18, 32 (top), 33, 45 (bottom), 68, 80,
94 and 96 © Tim Piggins
pages 69 (bottom) and 81 © Joe Francis Dowden

Design copyright © Search Press Ltd. 2003

ISBN: 978 1 903975 00 8

The Publishers and author can accept no responsibility for
any consequences arising from the information, advice or
instructions given in this publication.

The publishers would like to thank Winsor & Newton for
supplying some of the materials used in this book.

Suppliers
If you have difficulty in obtaining any of the materials and
equipment mentioned in this book, please visit the Search
Press website for details of suppliers: www.searchpress.com

Alternatively, you can write to the Publishers at the address
above, for a current list of stockists, which includes firms
who operate a mail-order service, or you can write to Winsor
& Newton requesting a list of distributers.

Winsor & Newton, UK Marketing
Whitefriars Avenue, Harrow, Middlesex HA3 5RH

Publishers' note
All the step-by-step photographs in this book feature
the author, Joe Francis Dowden, demonstrating how to
paint water. No models have been used.

There are references to sable and other animal hair
brushes in this book. It is the publishers' custom
to recommend synthetic materials as substitutes for
animal products wherever possible. There is now a
large range of brushes available made from artificial
fibres, and they are satisfactory substitutes for those
made from natural fibres.

Printed in Malaysia

*My thanks go to Tim Piggins, for photographing some of
the paintings in this book, and to Joy Mead, Paul Bailey,
Ollie Strotten, Mike Reed, Andrew Street, Alan Witt and
Philippa Cousins, and Peter and Trish Lebus for their
continued help and encouragement.*

*I would also like to express my gratitude to Malcolm and
Margaret Clarke, Alice Purvis, Nigel and Carol Bonham,
Diane and Peter Jeorrett, Tony Reed, David Savage,
Malcolme Sharp, Michael Baxter, Handa Bray, Charlie
Ward, Margaret Elston, Jim and Shirley Farrar, Gerald
Madgewick, Graham Ewesden and Doris Campbell – the
farmers, landowners, estate managers, small holders,
and the rural craftsmen and women who look after the
countryside I paint.*

Page 1
Mountain Lake
Size: 460 x 320mm (18 x 12½in)

*This ribbon of tranquil water, set in clear mountain air among
soaring crags, appears mirror smooth, but the presence of as a
myriad of tiny ripples is revealed by the slightly blurred reflections.
The water was painted wet in wet, running many colours together.
A little gum arabic was used to stop the colours from spreading
out of control.*

Pages 2/3
Grey Day
Size: 405 x 305mm (16 x 12in)

*There seemed little in the way of composition or light to excite
the eye on the cold winter's day when I painted this image in
situ. There was lots of interesting movement, however, so I used
loose, expressive brush strokes to depict this. When the initial grey
river wash was dry, the reflection colours were painted on with a
combination of wet on dry, wet in wet and dry brush techniques.*

Opposite
Mud Banks and Woodland
Size: 485 x 320mm (19 x 12½in)

*Large quantities of water were used to achieve the wetness of this
river where it breaks and spreads across mud shallows. Further
away the water was worked very wet; cadmium lemon is the key
colour, with phthalo green, burnt sienna, and Payne's gray added
in many blurred verticals. The foreground water was painted with
crisscross strokes from the tip of a well-pointed brush. The mud
banks and other bright details in the water were masked before
any colours were applied, then, at the finish, the point of a knife
was used to scratch a few upright sparkles.*

Contents

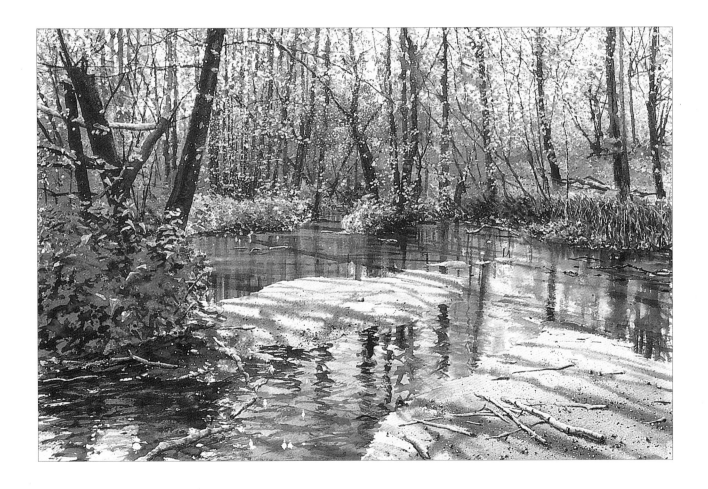

Introduction

Water forms the medium of watercolour; pigment flows naturally through it, and when the water dries that movement is frozen, perfectly capturing the movement of light on water. Its natural translucence makes it ideal for creating water itself and in this book I paint light and water, using the properties of water to achieve effective, realistic and dramatic results.

When painting a picture, I like to create powerful images that evoke the senses and draw out the mood and atmosphere of the scene in front of me. Sunlight is tremendously powerful, it cannot be looked at directly, but it lights the land with its wonderful brilliance. Perhaps there is the sound of a babbling brook, the aromatic leaf litter of a riverside forest, the crunch of shingle or the bracing cold of a sparkling stream. We can perceive and feel all these things in a three-dimensional world, because they are all around us. When working within the narrow spectrum of tone and colour it is a little different, but it is still possible to create immensely powerful mental triggers which make a painting look and feel real. They literally delude the observer – little acts of visual chicanery, deployed to trick the eye. The visual mind will say 'I know that's water, but it can't be because what I am looking at is a painting, so how did the artist achieve it?' Well, I am going to reveal my techniques to you and show you how I paint water.

Basic principles are demonstrated early on in the book with hints on capturing light, colour and texture. I include tips and techniques to help boost confidence and improve skills, and six step-by-step demonstrations which highlight particular facets of capturing water in all its moods. Many paintings are featured throughout the book, each of which was chosen to illustrate a particular point.

There are easy ways of doing most things, but you have to learn how to do them. Some of them are profoundly simple, others illustrate how to make pictures look extremely realistic. Once you know how to paint still and moving water, and how to create reflections, you will be able to enjoy the wonderful qualities of watercolour and start on your own artistic journey.

Here is how I do it. Enjoy the book and happy painting!

Opposite
Sunlit Lane
Size: 255 x 380mm (10 x 15in)
A large loose wash was painted virtually all at once with many colours run in, leaving the puddles as white paper. When this was dry, the puddles were rewetted, then an upside-down sky was painted, wet in wet, in each – miniature washes of phthalo blue and indigo, dark at the bottom, light at the top, getting progressively lighter for the more distant puddles. The landscape and road colours were light red and indigo. Phthalo blue, cadmium lemon and burnt sienna were also used in the landscape. The puddles were enhanced by painting contrasting darks around them.

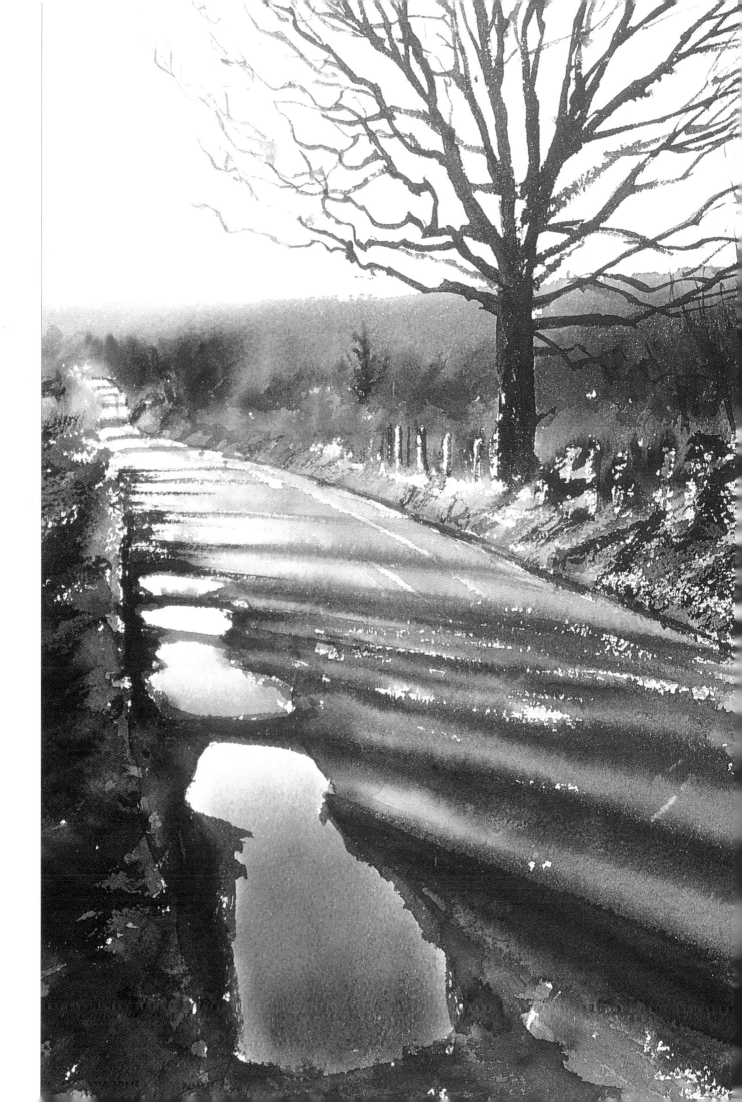

Materials

It is not the materials themselves that matter but what you do with them. The greatest triumphs can often occur in the face of adversity, especially when painting in the open air without the comfort of the studio or a set of ideal materials to hand. For me, materials are part of the enjoyment of watercolour, so, apart from the essentials (colours, brushes and paper), I have a few *extra* items in my workbox which help make painting with watercolour more enjoyable!

Colours

Phthalo blue *is a near-primary blue. It is useful in skies where I often mix it with a little green. It also forms the basis for blue sky reflections in water.*

Ultramarine blue *(or French ultramarine) is a warm blue from which good violets can be made. It is useful on its own for distant landscape blues. Mix with burnt sienna for a range of greys.*

Cobalt blue *is a cool blue. It is a traditional sky blue, and, sometimes, I mix it with phthalo blue. Also used as the base for subtle greys.*

Phthalo green *added to cadmium lemon makes the range of intense greens that I use. Start with a lot of cadmium lemon and add a little phthalo green. You can also warm it with burnt sienna. You could mix greens from phthalo blue and cadmium lemon, but a tube of ready-mixed colour is easier.*

Cadmium lemon *makes all the other yellows, but you cannot mix a lemon yellow from any other. Cadmium lemon lacks transparency, but it does have mixing power, and you do not get both qualities in one pigment. In any case it will still behave transparently in practice. Mix it with touches of quinacridone red to make lovely oranges.*

Quinacridone red *is a crimson red which will make good violets when mixed with blue, and a fire-truck red when mixed with touches of cadmium lemon. Cadmium red could be a later addition to your palette, but it is not such a versatile colour for mixes.*

Burnt sienna *is a lovely transparent oxide brown – wonderful with the blues in a range of mixes for endless subtle warm and cool greys, and brilliant on its own.*

Payne's gray *can be used as a darkening agent. I use it as a virtual black, sometimes mixing it with phthalo blue for intense dark.*

Sometimes, I paint with a very limited palette, or deliberately avoid using my favourite colours, so that I have to try new ones. This practice helps continue the learning process and prevents me from feeling stale. Always try to be open minded and experiment with new colours.

It is surprising how much you could paint with just three near-primary colours (cadmium lemon, quinacridone red and phthalo blue), but, more realistically, the eight colours shown left would make an immensely versatile palette. Buy them in larger tubes as it is less expensive in the long run. There are three blues, one green, one yellow (but no orange), a crimson, an earthy golden brown, and a heavy duty grey which can be used as a black. I have included three blues because it is hard to do without them and it is difficult to duplicate them by mixing.

The colours I use most are cadmium lemon, burnt sienna, and to a lesser extent ultramarine blue.

The next colours to add to your palette could be those shown opposite.

Tip Useful greys

Useful greys can be mixed with phthalo green and quinacridone red. A touch of the red in the green makes a great pine-tree colour. Gradually add more red to create a fascinating range of complementary greys. Beautiful greys for skies can be obtained with cobalt blue or ultramarine blue mixed with burnt sienna and quinacridone red.

TIP COMPLEMENTARY COLOURS

If you do not know what colours to use to get a good result and make something really beautiful, try constructing a painting in which two complementary colours predominate. Complementary colours look great together; each provides the after-image of the other within the eye, making them zing and spark off each other. For example, try using violet and yellow for the sky and water in an evening scene, crimson poppies in a green field, or orange autumn leaves against blue sky and water. Mixes of each pair of colours will make greys that can be used for the darks in the same painting – a partial guarantee that you will achieve colour harmony. The painting at the bottom of page 15 is a good example of using complementary colours

Yellow ochre *is a summer meadow yellow – the colour of a field of ripe barley.*

Cerulean blue *granulates beautifully and is an opaque, slightly greenish blue, sometimes used in skies.*

Naples yellow *is a creamy yellow mixture of several pigments in one package. It can be used as a medium for mixing other colours into an evening sky.*

Cadmium red *(light or middle) is a tertiary red, on the border between red and orange. A beautiful colour on its own.*

Cobalt turquoise light *is another tertiary colour. It is an almost iridescent turquoise made of several pigments. It can be used as a body colour over darker colour. I use it to get distance and depth in my woodland landscapes.*

Light red *is a brick red which is the perfect colour for roofs and walls of old houses.*

New gamboge *is a luminous transparent colour that creates the sunlight on a hillside better than anything else. It allows the whiteness of the paper to provide the light and is a modern, permanent version of gamboge.*

BRUSHES, WATER JARS AND PALETTES

Using good-quality brushes can help improve your painting skills. I like to paint with sable brushes as their hairs return easily to a point, they hold a good quantity of colour and they have the capacity to release it steadily. Less expensive, synthetic and mixed-fibres brushes also point well and I have used them extensively even though they do not perfectly mimic the qualities of sable. The larger sizes, however, do not clean as quickly as sable, so take this into account when changing colours while working rapidly.

Although I own a wide selection of brushes, most of my work is painted with a No. 8 or a No. 12 round brush, but a No. 16 is useful for large washes. A fan blender is the best brush for softening multicoloured washes.

Try to avoid mixing paint with your best sable brushes. Wash all brushes gently in cold water. You could use a little vegetable-based, artists' brush-cleaning soap. Never use ordinary soap or detergent.

My water supply consists of a glass jam jar in a paint kettle. I fill both with water, then use the water in the kettle for cleaning brushes and that in the jar for mixing colours.

There is a wide range of palettes available for artists, but I prefer to use old plates and saucers.

It is always worthwhile to have more than one brush of each size.

My water supply.

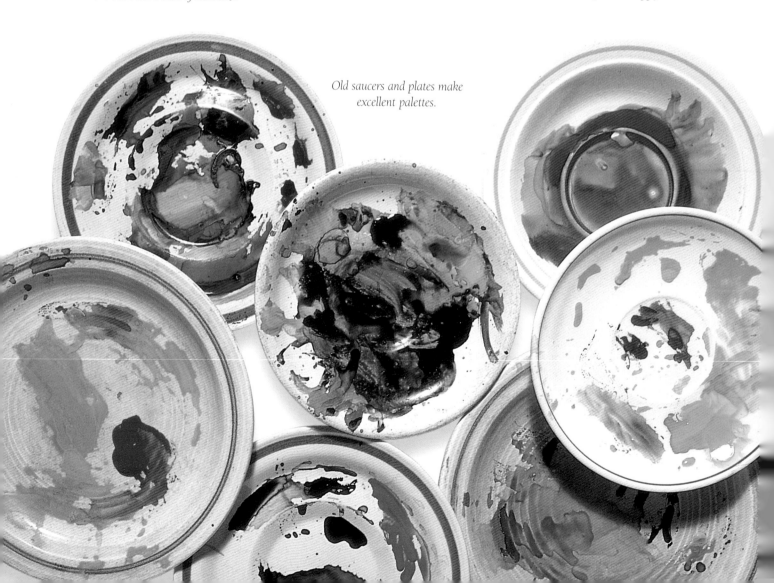

Old saucers and plates make excellent palettes.

PAPER

There are four basic characteristics associated with watercolour paper: surface texture (or tooth); weight (or thickness); whiteness; and hardness. They react differently to watercolour, and it is well worth experimenting with different types of paper.

Surface texture

There are three types of surface finish Hot pressed, Not (or cold pressed) and Rough.

Hot pressed paper is pressed between hot rollers to give a smooth surface. It is fine for some artists, but I hardly ever use it.

Not paper is pressed through rollers and felt mats. It has a subtle surface texture between moderately smooth and slightly rough which does not leave its *signature* in a painting, and I use it for most of my paintings. The term *Not* is another way of saying 'not hot pressed'.

Rough paper is not pressed at all, and the texture can be *very* rough on heavier papers. However, by controlling water and colour, you can get a smooth sky wash or a grainy/broken effect.

Weight

The imperial method of paper weight (in pounds) refers to the total weight of a ream of paper. A 90lb sheet is thin and papery, whereas a 300lb paper is heavy and thick. Nowadays, most paper weights are given in gsm (grams per square metre) units, from 150gsm to 640gsm. Watercolour paper cockles when wet, so I always stretch it. Heavy papers will take more colour and give a more intense finish than lightweight papers.

Whiteness

The 'whiteness' of paper varies considerably, but the mellower-toned papers still read as white when whites are saved. I seek out the whiter papers for river scenes.

Hardness

The hardness of papers also varies. Masking fluid, for example, can rip softer papers when it is removed. It will not harm harder papers but it can lift some of the underlying colour when laid over it. Soft-surfaced papers are sensitive and can be used for building up subtle textures. Some tearing caused by removing masking fluid can enhance the final image, as with jagged sky holes in a woodland. For detailed masking, I use a harder surfaced rag paper.

Stretching paper

I stretch all my paper before starting to paint. I thoroughly soak the paper in water, lay it on a wooden board for a few minutes to let it expand more, then staple it to the board. I keep the staples close together on papers below 425gsm (200lb) and set the line of staples just in from the edge of the paper – if they are too close to the edge the paper will rip. Leave until the paper is thoroughly dry and taut. I cut the finished painting off the board, then use a tack lifter and a pair of pliers to pull the staples from the remaining strip of paper.

Hair dryer

I use a **hair dryer** to save drying time – in fact, I have two of them in my work box. However, you must dry work evenly to avoid still-wet colour running back into drying areas.

Resists and mediums

Masking fluid can be used to protect the paper surface from layers of colour and left to dry. When peeled off, the underlying paper or pigment appears. Use old or cheap brushes to apply the fluid because it ruins them. Colour shapers, ink nibs and toothbrushes can also be used to create different marks with the masking fluid.

Wax candles rubbed over the paper or a dry wash will resist overlying washes to create a subtle grainy texture.

Gum arabic and **watercolour medium** added to a wet wash will slow the passage of paint through the water and allow you to get the wet, soft focus look of reflections. Use sparingly.

Granulation medium can be used to enhance the granulation of some colours.

Tip Granulation

The granulation effect of some colours can be used to create a beautiful grainy texture. It works best with the board tilted away from you, and the painting left to dry naturally – the pigments settle into the undulations in the surface of the paper. Cerulean blue, ultramarine blue, cobalt blue, manganese blue, viridian, cobalt violet, ultramarine violet and raw umber are usually good granulating colours, but the characteristic does vary with different brands. Granulation medium can be used to enhance the effect.

Gum arabic, watercolour medium, masking fluid and a candle can all be used to help make water look wet.

This enlarged detail, taken from the seascape demonstration (see page 64), shows the granulation of ultramarine blue mixed with granulation fluid and touches of burnt sienna and quinacridone red.

*A **colour shaper** is my favourite masking fluid applicator. It can be used to create many shapes and is easy to clean.*

*An Indian **ink nib** is good for fine detail. Ruling pens do flow better and you can adjust the line thickness, but they can leave blobs.*

*You can flick specks of masking fluid from a **toothbrush**, either by dragging your thumb across the bristles to create a spray of fine dots, or by banging the brush down against the palm of the hand for droplets. Clean toothbrushes by immersing them in a cup of hot water, then combing the bristles with a strong needle.*

*A **ruined brush** covered with dried masking fluid is great for masking rough natural shapes, such as leaves and woodland sky-holes.*

OTHER EQUIPMENT

Apart from sharpening pencils and cutting stencils, a **craft knife** can be used to scratch tiny marks on the paper (perfect for sparkles on a river). You can also incise the surface and peel off slivers of paper to give extremely sharp whites, but, take care, as this may spoil the image. I use **scissors** for cutting paper masks and stencils.

I use lengths of **masking tape** to mask the borders around my paintings for a neat finish. It can also be cut to shape with a craft knife and used as a resist.

I make stencils with ripped up pieces of **scrap paper** when spattering colour. The natural look of torn edges is ideal for masking a river-bank. Stick torn edges together to make a complete river bank shape. You can also cut shaped apertures in scrap paper and scrub through these with a damp brush to lift out colour to that shape – a good technique for underwater stones and branches in trees.

I draw final compositions on **tracing paper** then transfer them on to the watercolour paper

I use pieces of **paper towel** to dab off excess colour. Use it damp or dry to lift out clouds from wet skies, and for other effects. Try twisting it into coils to create mares-tail clouds. Always use a clean part of the paper for each dab. Dabbing twice with the same piece will just imprint paint from the previous dab!

I use a B grade **pencil** and an eraser for sketching. I do not use an eraser on watercolour paper as it can damage the surface.

Use artists' **brush-cleaning soap** sparingly with cold water to extend the life of sable brushes.

A pencil and eraser, a craft knife, a roll of masking tape, a pair of scissors, scrap paper, tracing paper, paper towel and a bar of artists' brush-cleaning soap complete my essential set of equipment.

TIP COLLECT UNUSUAL ITEMS FOR YOUR WORK BOX

Expand your repertoire of techniques and your ability to express the world around you by experimenting with unusual items. I blow through a drinking straw to control washes and fine tune an image. I use small pieces torn from a sponge to create a variety of textures. Sometimes, I use a small bristle (bright) brush to gently scrub out highlights on fence posts, trees, etc., but take care not to damage the paper fibres because they will then absorb colour deep into the paper. Tiny woodcock's pinfeathers, taped to an old brush handle, can produce amazingly long fine lines. I have even used a seed head of grass, a toothpick, the edge of a piece of card, and a coiled-up piece of typing paper to create particular textures.

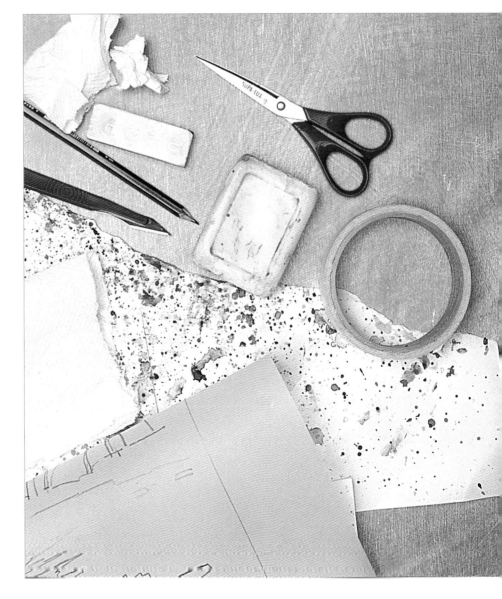

Making water look wet

Whether it is a splash of water on the edge of a quiet lane, or a deep river gliding smoothly towards the ocean, water has the same basic quality; it is colourless and transparent – effectively invisible. You cannot paint the invisible, so what do you paint?

Well, water has another quality in that its surface moves, diffuses and breaks up light: mirroring it in reflections; distorting it in ripples; and bending it in refraction.

Painting is all about recreating surface colours and textures. Although water has a surface, the colours we see on that surface are those reflected on to it. So, do not paint the surface of water, paint what it reflects, because that is what you see – reflections.

Most land-based objects head skywards; buildings, fence posts, trees, plants, people, all are upright, but their reflections go in the opposite direction. So that is what you can paint – things going down.

Water also tends to elongate texture vertically because of movement. It moves light up and down in a kind of reciprocating motion. Painting vertical texture implies a small amount of this up and down rippling movement. Perfectly smooth water will give perfect, pinpoint reflections, but such smooth water is rare. All reflections tend to be blurred. Smooth shining water is nearly always covered in tiny ripples and these soften the light and blur the reflections. So, if you paint blurred and vertical reflections, water will look wet.

Except for bright lights, reflections mirror the dimension of the subject reflected. To be a bit technical (for which I apologise) reflections mirror the subject about the point at which the horizontal plane of the water intersects the subject. But, do not worry about rules. It is much easier to get the feel of water – just look at your reference material or the view in front of you to see what is happening.

On these and the following pages, I have included coloured sketches of different types of water with captions about how I painted them.

Rapid application of lots of colour wet in wet

This stretch of water was started as an upside-down sky – a wash of phthalo blue and indigo painted wet in wet. The blue in the foreground is darker than that of the visible sky for two reasons: it is the reflection from high overhead (the sky is often darker up there); and it also takes some colour from the river bed. When the first wash was dry, I dashed clean water all over the area of tree reflection leaving a few dry patches, then brushed in a base layer of cadmium lemon. Keeping the saved whites, I dragged touches of phthalo green, burnt sienna and Payne's gray downwards into the wet wash. I added a little cobalt turquoise light in the distance, and teased a few rough marks out of the wet area on to the dry sky reflection to create a slightly rippled edge.

Mud colour contrasts well with light, bright colours

After building the strong tones around this image, I painted the upside-down sky wash in the water with phthalo blue, indigo and a little quinacridone magenta. The dark reflection was a single wash of burnt sienna and cadmium lemon painted separately onto a wash of water, and added to with Payne's gray and phthalo green. The rich brown comes from the mud on the river bed. Rivers often have this colour in their reflections - think of varnished teak instead of dirty mud.

Leave puddles as white paper and paint them last

Water is a small but important feature in this composition. The surrounding tones provide contrast and were completed before any work was carried out on the puddle. I used burnt sienna and ultramarine blue as a grey undertone of the puddle, leaving some white areas in the distance to give it light, and pulling some of the landscape colours down into it to form the reflections. When this was dry, I brushed on the dark, hard-edged reflections. Note how the area of dark mud contrasts with the bright reflections

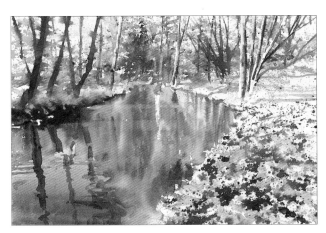

Many colours blended together make rich, deep water

The foliage was spattered over a dry glaze of cadmium lemon, using a similar technique to that shown on page 50. After the upside-down sky and reflection washes were dry, I brushed loose, angled tree reflections down into the water, giving them a few vertical squiggles of the brush on the way down. Look carefully at the trunk reflections; they are not straight diagonals, they go straight for a while, and then give a little kick.

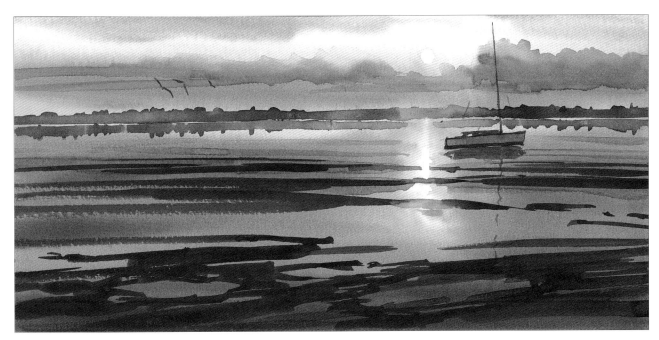

Masked out whites and strong contrasts create impact

The sun and its longer reflection were masked out, then a wash of Naples yellow was painted over most of the image, diluting it around the brightest areas. Into this was worked quinacridone red and phthalo green mixed on the palette. These colours give anything from a grey green through black to grey crimson. I put more dark colour into the water than the sky. When dry, I painted the clouds wet in wet and the dark streaks wet on dry, reddening them near the bright area with quinacridone red and Naples yellow, before painting the boat and the gulls. These muddy colours work because they are set against strong lights and darks.

15

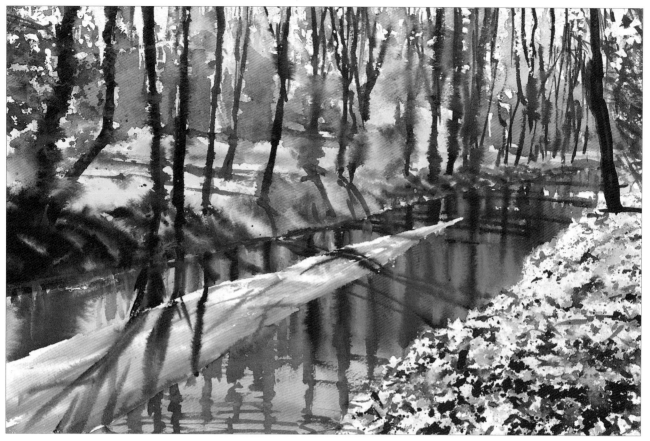

Vertical reflections, both sharp and soft focus, read as wet

Vertical reflections contrast with angled shadows across this river. The jagged-edged mud bank was masked out, and the river painted as an upside-down sky. This was then glazed over with reflected colours. The dark reflections were worked wet in wet, then the colours were dragged out of the wet area on to dry paper. The shadows give a deep sense of perspective. Starting from closely-spaced horizontal lines in the distance, they widen out and change to diagonal lines in the foreground.

Complementary blue and orange washes work together

When painting the intense blue and orange washes for sky, water and woodland, I left the boat and its reflection white, and added various darks into the river reflection wet in wet. When these washes were dry, I used the point of a brush to paint simple horizontal streaks across the river to indicate movement on the surface. These diminish in width and spacing as they get further away, giving perspective to the composition.

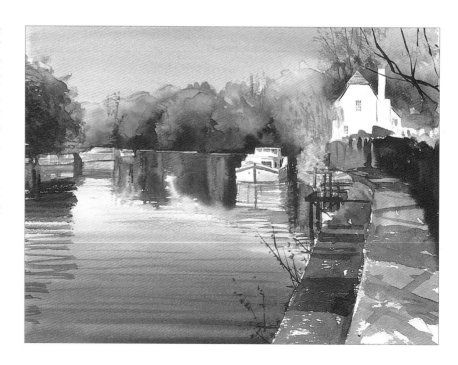

Build tone with several glazes

A disappointing grey day for an on site painting led me to use the red of this dredging rig to provide a contrast to the grey. Several grey washes were laid one over the other, and the foaming sea was left white. The distant whites are breakers on submerged reefs and these were scratched out with a knife. The water diffuses light, with few distinct reflections, but there are still a few reflections from the rig. The lines of waves were painted wet on dry – making them narrower and closer together as they get further way enhances the perspective.

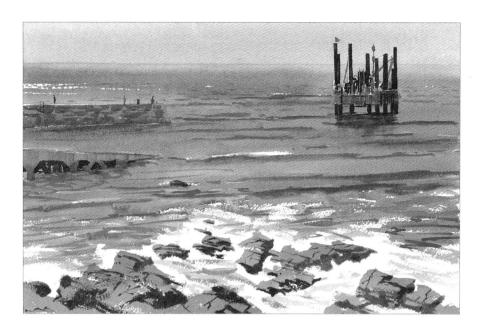

Mask the bridge and paint water with a single wash

Once the perspective lines for the river and path were established, I loosely masked the bridge, some of the distant trees, some sky holes, and some foreground leaves. When all the foliage had been painted, I wet the river and brushed in a wash of phthalo blue and indigo from the bottom up and let this dry. I then brushed a lot of water on to the river behind the bridge, added a little gum arabic in the middle distance area, then applied a base layer of Naples yellow. Working wet in wet, I then added the other river colours – burnt sienna, cadmium lemon, phthalo green and Payne's gray. Before these colours dried, I brushed some darks from the palette to indicate the shadows across the water. I also used the darks to brush in the foreground reflections very wet and loose.

TIP LIGHT SOURCES

Choosing lighting conditions is as important as the choice of subject matter, and the location of the light source is as important as that of the scene. Bright light, early or late in the day produces strong compositions. A low angled sun gives interesting definitions, shadows and colours: the sun glitters through leaves; trees are better defined with strong light and shade; and patterns of tones are strong. During the summer, when I paint out of doors, I avoid painting when the sun is high overhead because it tends to flatten tones, making it difficult to create interesting compositions. I find my best times for composing light are early or late in the year.

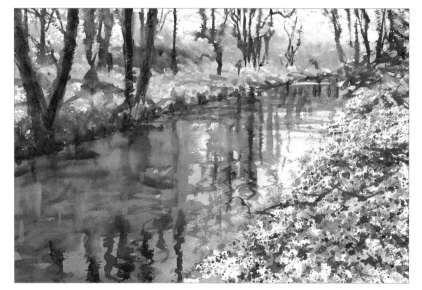

Light, opaque colours, wet in wet, on top of dark tones work well

Colour was dragged around very loosely in the reflections, leaving plenty of white paper. Darks were crisscrossed over the river bed to indicate the shadows of branches, then opaque cadmium lemon was streaked downwards, wet in wet, to give depth and colour

Composition

No one can explain why one way of depicting a particular view is enjoyable to look at, and another is not. We do not just see, we enjoy the process of seeing. Fortunately for the artist, people are widely in agreement about what looks good. They may not know what they like, but they know when they see it. Our job as artists is to know what people like before they see it – and paint it! Composition is about how visual information can be presented. On these and the following pages, I give a few guidelines to help create good compositions.

ELEMENTS OF A COMPOSITION

Dividing a completed painting into segments shows how it was constructed. Many compositions can be broken down into the following segments: the foreground, the middle distance, the far distance, the horizon and sky and linking elements.

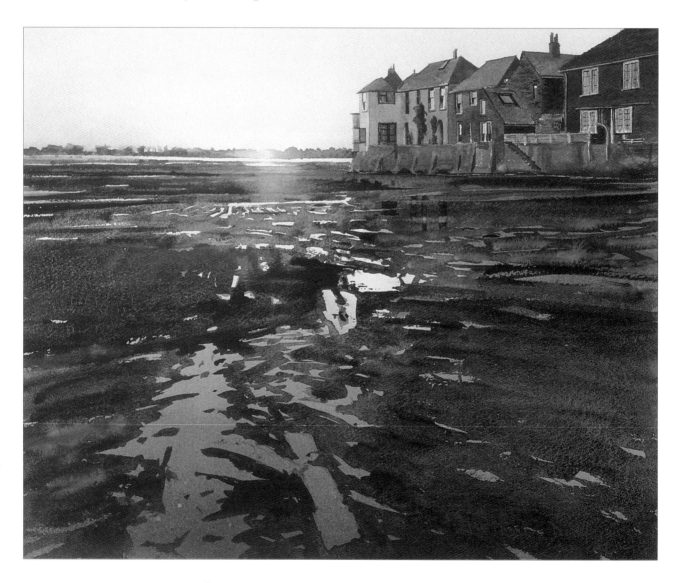

Horizon and sky area

Linking element

Far distance area

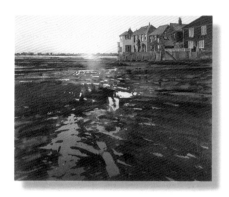

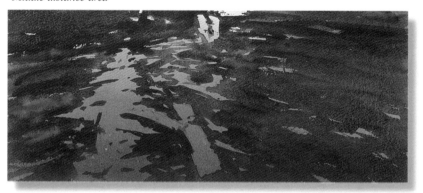

Middle distance area

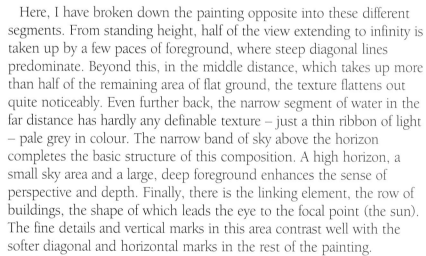

Foreground area

Here, I have broken down the painting opposite into these different segments. From standing height, half of the view extending to infinity is taken up by a few paces of foreground, where steep diagonal lines predominate. Beyond this, in the middle distance, which takes up more than half of the remaining area of flat ground, the texture flattens out quite noticeably. Even further back, the narrow segment of water in the far distance has hardly any definable texture – just a thin ribbon of light – pale grey in colour. The narrow band of sky above the horizon completes the basic structure of this composition. A high horizon, a small sky area and a large, deep foreground enhances the sense of perspective and depth. Finally, there is the linking element, the row of buildings, the shape of which leads the eye to the focal point (the sun). The fine details and vertical marks in this area contrast well with the softer diagonal and horizontal marks in the rest of the painting.

Although there are exceptions, I usually keep my horizons away from the centre. I use a high horizon and a small sky when there is plenty of interest in the foreground. On the other hand, when there is more interest above eye level and/or in the sky, a low horizon and shallow foreground can work well.

Similarly, I usually place objects of interest (focal points) away from the middle. Although the far end of the row of houses in this example is near the middle, the sun dominates the scene and moves the emphasis towards the left.

TIP FOCAL POINT

In simple terms, composition is about where the focal point is placed, and it takes resolve and planning to decide on this position. When we look at a scene, we tend to seek out the most interesting part and concentrate on that, placing it in the middle of the view in front of us. In a painting, however, the focal point is best placed away from centre; the eye will still be drawn to it, but it will then wander round the other parts of the composition.

19

FORMAT

The format (shape) of a painting has a great deal to do with the composition. Formats can be used to solve problems: a panoramic view can be used to render a dramatic scene without having to paint any foreground. A long landscape can put grandeur into a scene. The proportions of a normal landscape format are roughly 6:4, and approximates to the area seen by the human eye. This can be shortened or lengthened to any shape required. I often paint to landscape-plus-a-bit, a slightly lengthened landscape. On a 760 x 560mm (30 x 22in) sheet of watercolour paper, this means using the full width, and reducing the height.

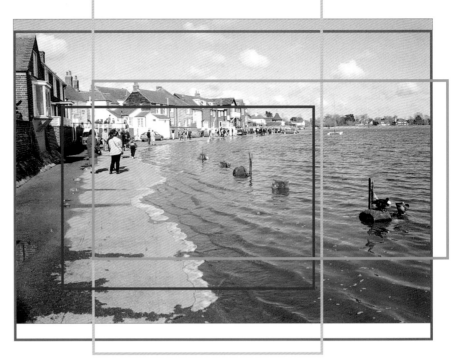

The scene in this photograph could be used to create a wide range of different-format paintings. The whole image is basic landscape format. The red rectangle is the same shape, but moving it down slightly lifts the horizon line to give more prominence to the foreground. The blue shape is proportional to the red one but smaller (you do not have to paint everything in front of you). The green rectangle is scaled to my panoramic format, while the orange rectangle shows the potential for painting a portrait shape.

Composition by selection

Choose the view, then choose the format. Instead of arranging subject matter inside a shape, arrange the shape around the subject matter.

This scene is just a few steps back up the lane from where the demonstration painting on page 34 was viewed. I chose to use a portrait format here to accentuate depth and perspective. I moved my viewing position to place the tree well to the side, to put the horizon above centre, and to make the lane lead off one side of the image. The position of the distant buildings leads the eye through the composition and emphasizes the bend at the end of the lane.

This painting can also be broken down into different segments. In this case, the linking element is the tree.

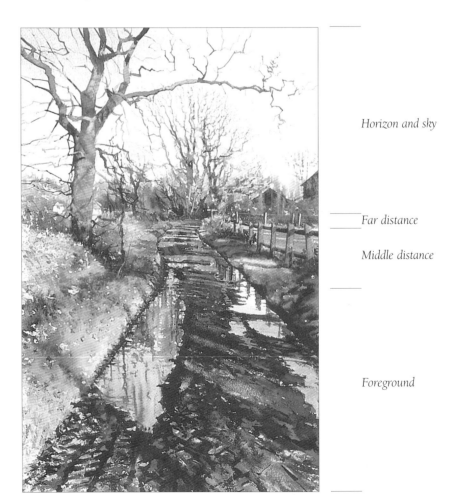

Horizon and sky

Far distance

Middle distance

Foreground

PERSPECTIVE AND COMPOSITION

The soft masses of the foreground grass and background woodland foliage conceal a sharp dynamic perspective in this image. The horizon (eye level) dictates the geometry of perspective. Here, a distinct horizon cannot be seen but its theoretical position is slightly above where the line of the land meets the distant woodland. Unlike a straight road or railway track, the perspective lines in this scene cannot be plotted with mathematical precision. The lines of river banks are especially hard to find when drawing the composition.

Nevertheless, they should ring true and not be wildly wrong. They should converge to a point (or points) along the horizon line. In this example, the edge of the left-hand bank of the river is relatively straight, so you could draw a line along this edge back to where it meets the horizon – the vanishing point. The best way to find the angle of the other bank is to draw another line from the vanishing point along which most of the bank sits. With these bones of perspective in place, you can weave the actual shape of the river around them.

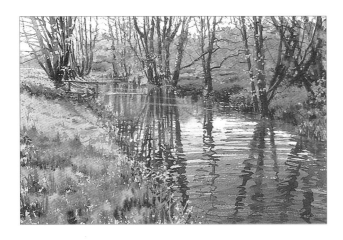

The illustration below shows this painting broken down into segments along the horizon and the significant perspective lines. The other characteristic of perspective is that images diminish in size and detail as they recede into the distance – compare the segments for each side of the river, and note how perspective affects the shapes and sizes of the ripples on the broad swathe of the river.

Flat still water

The fire of a setting sun sits like a mantle on the breathtaking serenity of an upland expanse of water. Is it possible to get light to look brighter than the white of the paper, to recreate the smoothness of the sky and water and to build up the subtle tones of colour and light?

Yes, it is, and in this project I show you how saved whites, wet washes, bright colours and inky dark tones can be combined to put the fire into such water scenes. Although some credit has to go to the people who make the materials, it is the way these materials are used that gets the results – the secret is to let water do the work for you.

I used the ten colours shown on page 24 to paint this picture, but there are many other colours that can be used to get the darks, the greys and the warm glowing sky colours. It is, however, vital to keep whites saved.

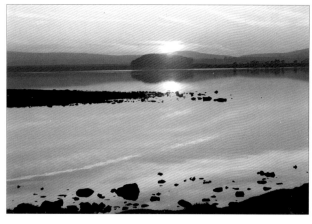

The photograph used as the reference for this painting. Notice that only three-quarters of the width of the image has been used, placing the focal point, the setting sun, off centre. I also decided to make the shapes of the foreground rocks more interesting.

The key here is to brush colours on to wet paper and let them spread and blend together and become beautifully smooth.

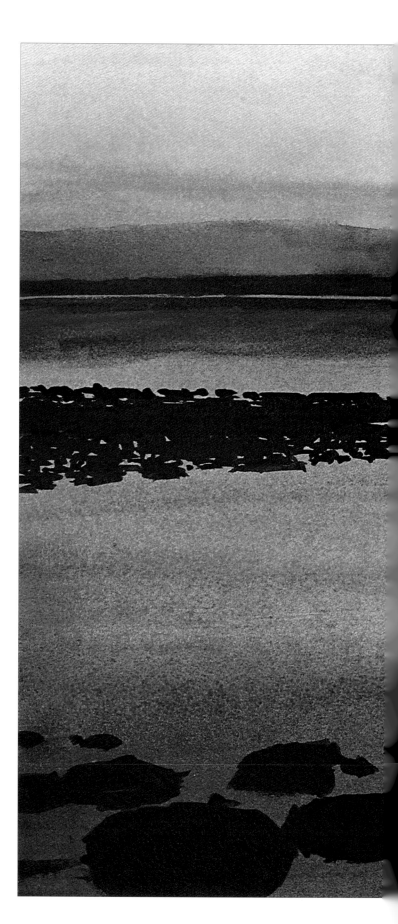

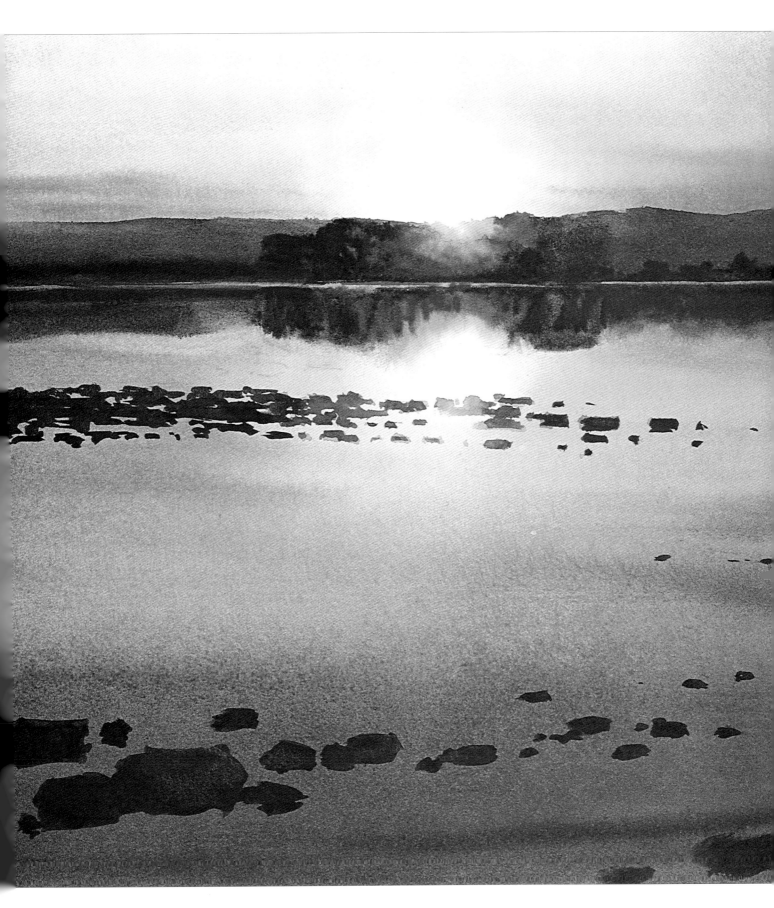

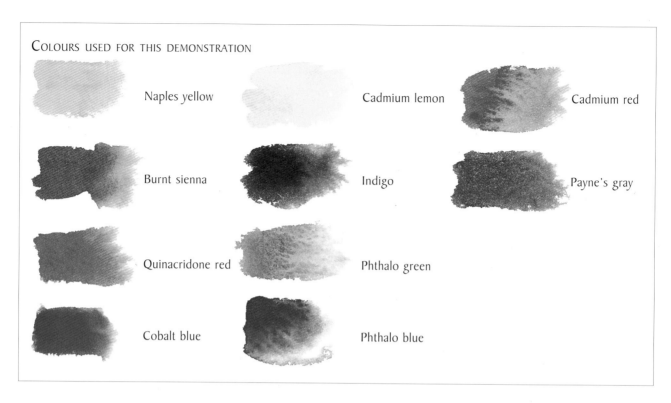

COLOURS USED FOR THIS DEMONSTRATION

Naples yellow

Cadmium lemon

Cadmium red

Burnt sienna

Indigo

Payne's gray

Quinacridone red

Phthalo green

Cobalt blue

Phthalo blue

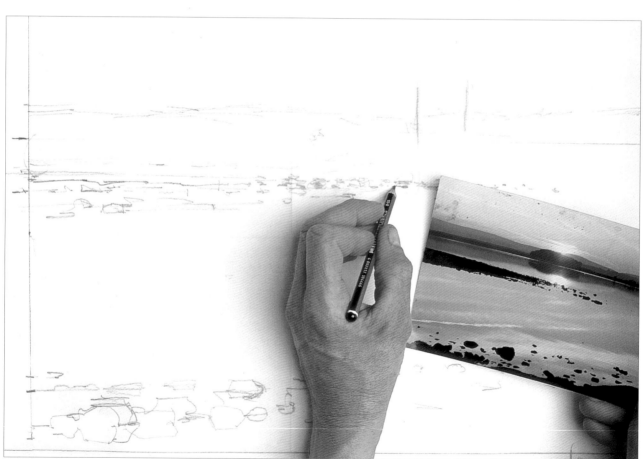

1 Using the reference photograph on page 22 and a soft pencil make a rough sketch of the composition. Here, I have determined a relatively high horizon line and I have drawn two vertical lines to indicate the position of the sun as I do not want my pencil marks in this area.

The finished sketch drawn from the reference photograph. I changed the structure of the foreground rocks to give added interest. I also drew two vertical lines to show the location of the sun and its reflection. The space between these lines will be the lightest part of the composition, and I do not want any pencil marks in this area.

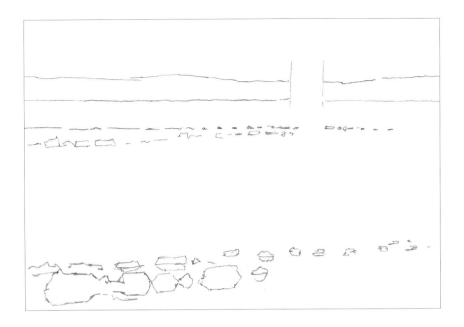

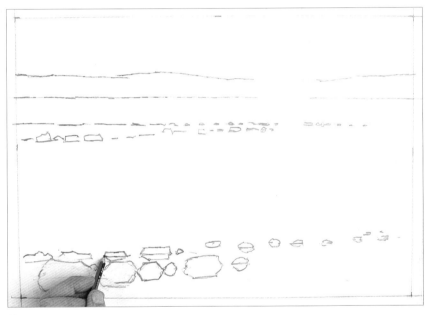

2 When you are happy with the composition, make a copy of it on tracing paper, then use this tracing to transfer the basic outlines, and the edges of the composition on to the watercolour paper.

3 Stick strips of masking tape round the outer edges of the composition.

TIP BLENDED WASHES

You need to work quickly to achieve a good blended wash, so decide on the colours you need, then set up your palettes.

Here I have set up my first four colours – Naples yellow, quinacridone red, burnt sienna and cobalt blue.

25

TIP HALO OF WATER FOR A HALO OF LIGHT

In this project, it is important not to allow any colour into the areas of the sun and its reflection, which need to be kept white. This can be achieved by using the characteristic of water that causes it to flow from a very wet area into a less wet area. I achieve this by making a reservoir of water surrounded by a ring of dry paper. I wet the rest of the paper, then apply colour wet in wet, working from the edges of the paper and weakening the wash as I get closer to the area I want to keep white. I release the clean water in the reservoir by dragging it across the dry ring. It then flows naturally into the less-wet surrounding wash, pushing colour before it and making a very soft edge. The key to this technique is to keep the reservoir wetter than the rest of the paper, and to retain it within the ring of dry paper until you are ready to use it. Repeat the process for subsequent glazes.

4 Use a clean brush to wet the whole of the paper, except for a diamond shape (for where the sun will be) and a circular shape (for its reflection, which will be just as white as the sun, but narrower). . .

5 . . . then, leaving narrow dry gaps, thoroughly wet the diamond and circular shapes to form the reservoirs.

6 Brush a wash of Naples yellow on to the wet paper. Work inwards from the edges of the paper, and make the colour weaker as you work closer to the dry lines round the sun and its reflection. Keep all colour off the dry lines.

7 Mix Naples yellow with a little burnt sienna and a touch of quinacridone red, then, working wet in wet, drop this colour along the horizon. Work inwards from the sides of the painting, taking the colour up into the sky and down into the sea weakening the wash as you work away from the horizon. Again, keep all colour off the dry lines.

8 Mix a wash of burnt sienna and dribble it across the bottom of the painting as shown . . .

9 . . . then spread it across the water area, reducing the tone as you work upwards to the horizon.

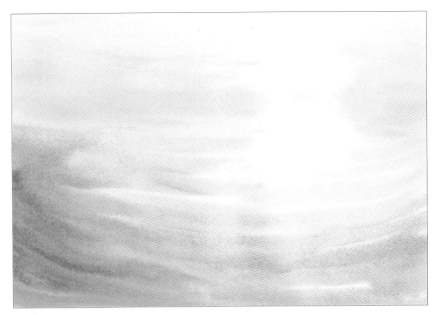

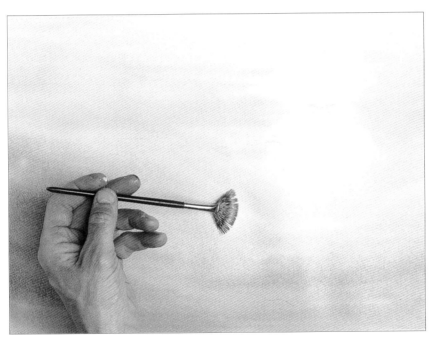

10 Use a fan blender brush to smooth all colours together.

11 Add even more water to the sun and reflection reservoirs, then breach them outwards, across the dry rings, into the less-wet surrounding colour. The water runs outwards into the surrounding wash and pushes colour away from the brightly lit areas to create the softest of edges.

12 Remove the masking tape borders, then use a hair dryer to dry the whole of the paper.

13 Replace the strips of masking tape and reinstate the reservoirs of water bounded by rings of dry paper for the sun and its reflection. Mix cadmium lemon with a little burnt sienna, then add this wet in wet to the area around the sun and reflection, keeping it slightly back from the dry rings to avoid distinct edges forming.

14 Lay in a wash of burnt sienna, starting at the bottom of the painting and weakening the wash slightly as you work upwards. Lay in more burnt sienna across the horizon working it up into the sky and down into the water. Brush touches of quinacridone red into the burnt sienna.

TIP CLEANING BRUSHES

You should always wash out brushes between colours. I like to have two water pots, one for washing out brushes and one for mixing colours (see page 10). Thoroughly clean all your brushes at the end of a painting session.

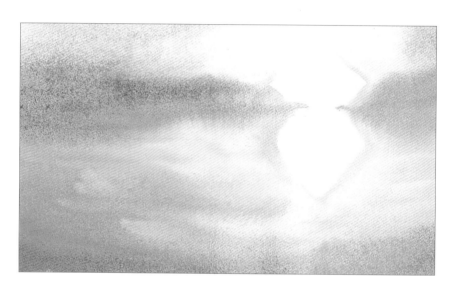

15 Introduce a wash of cobalt blue, weakening the colour as you work inwards from each side.

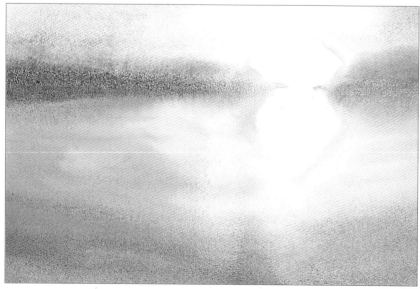

16 Add more cobalt blue in the sky, run this across the horizon and across the bottom of the water.

17 Add more water to the reservoirs, then breach them outwards again so that water flows into the yellow marks and softens the inner edges of these. Add streaks of cobalt blue clouds and streaks of burnt sienna across the water. Remove tape again and dry.

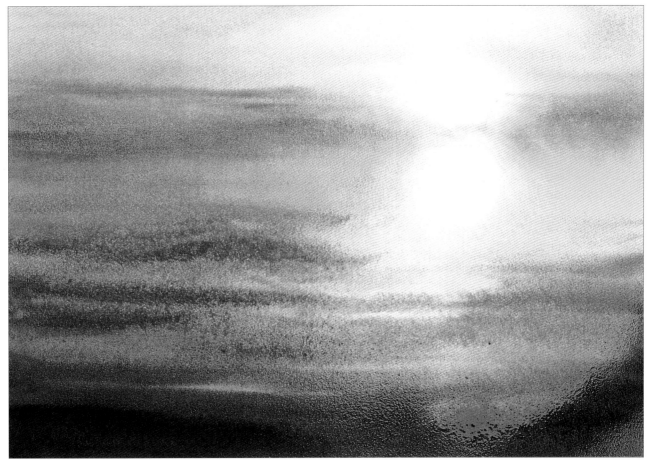

18 Reinstate the reservoirs within dry rings in the areas of the sun and its reflection. Wet the entire paper, then brush Naples yellow, quinacridone red, and burnt sienna separately into the sky and water washes, wet in wet. Glaze touches of cobalt blue over the lower part of the sky, from the horizon upwards. Add some quinacridone red and lay in horizontal streaks of this colour above and below the horizon. Strengthen this colour in the water. Using a mix of indigo with a little phthalo green, block in the foreground, streaking it across the water. Weaken the wash as you work upwards.

19 Fan blend the colour across the paper. Add horizontal streaks of cobalt blue below the horizon to define the reflections of the distant hills, then strengthen these with a mix of phthalo blue, phthalo green and indigo.

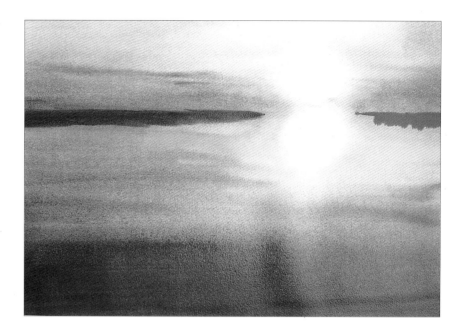

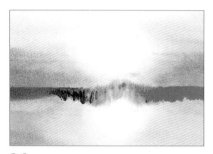

20 Add touches of cadmium lemon and cadmium red to the top part of the sun's reflection, then blend these into each other and across into the reflections of the distant hills. Add short vertical strokes of the dark mix to link the left-hand side of the dark reflection to the red and yellow.

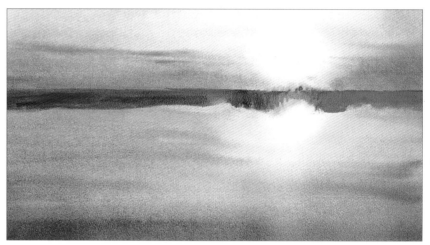

21 Use cobalt blue and the indigo mix to redefine the bottom edge of the reflection, then blend all colours together and leave to dry.

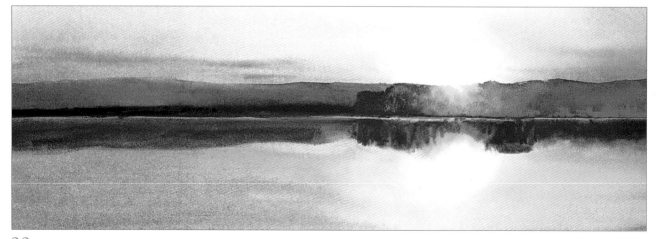

22 Wet the area of the distant hills – then brush a dark mix of phthalo green, indigo and phthalo blue into these hills, wet in wet, leaving a thin highlight between them and their reflections. Do not take this colour into the area below the sun. Mix cadmium lemon and cadmium red, then add the highlight on the hills in a similar way to that for the reflection. Darken the base of the hills, then leave to dry.

30

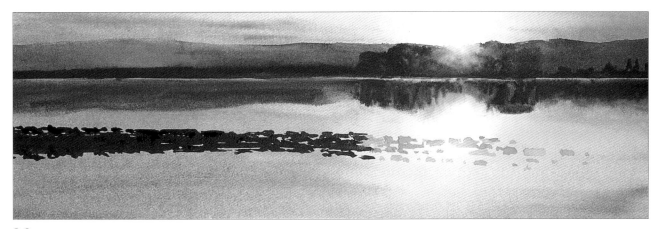

23 Use Payne's gray to block in the distant rocks. Use burnt sienna and touches of cadmium lemon to block in the those lying within the area of the sun's reflection, and darken this mix with Payne's the rocks approaching the glare zone

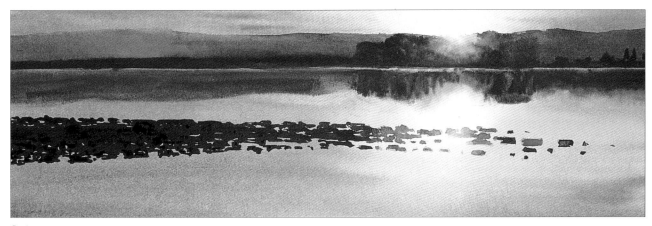

24 Darken the rocks at the extreme right-hand side and gradually reduce the colour as you work back into the bright reflection. Leave to dry.

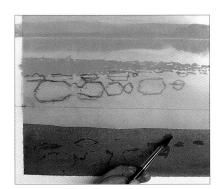

25 The dark glazes in the foreground will have obliterated the pencil marks for the rocks, so use the original tracing as a reference to redefine their shapes, then block them in with Payne's gray.

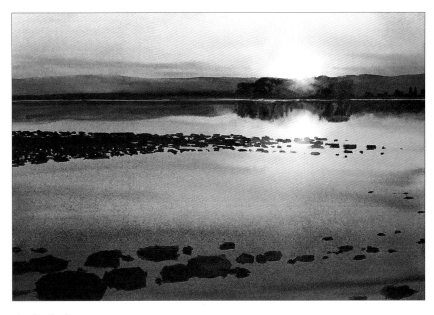

The finished painting

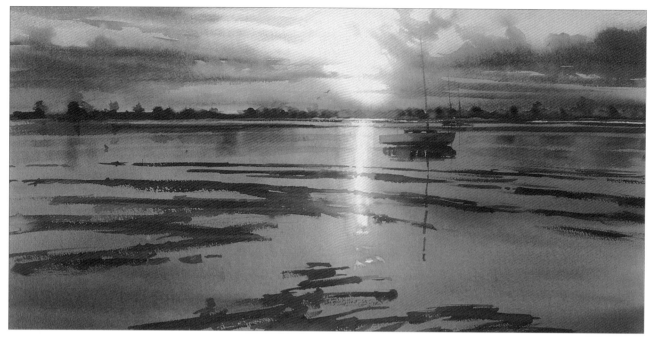

Shifting Tide

Size: 430 x 210mm (17 x 8¼in)

Deciding the overall colour of an image early on is a useful key to harmony. Burnt sienna, alizarin crimson and cadmium lemon provided the mixes for the reddish browns in this composition. The greys and intense darks are the result of adding ultramarine blue to the mixes on the palette, but I often use Payne's gray and indigo. Cadmium red provides the fiery red of the sun, and the whites were saved from the start.

Mud Flats

Size: 660 x 420mm (26 x 16½in)

Elongated landscape formats can add drama to an otherwise simple scene. Here, the long narrow sky and the deep foreground area combine to give a sense of distance, whereas the very narrow strip of water creates a wide expansive landscape and provides scale to the composition.

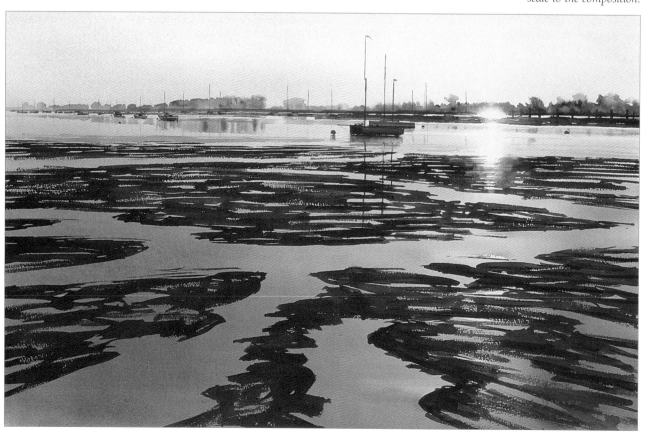

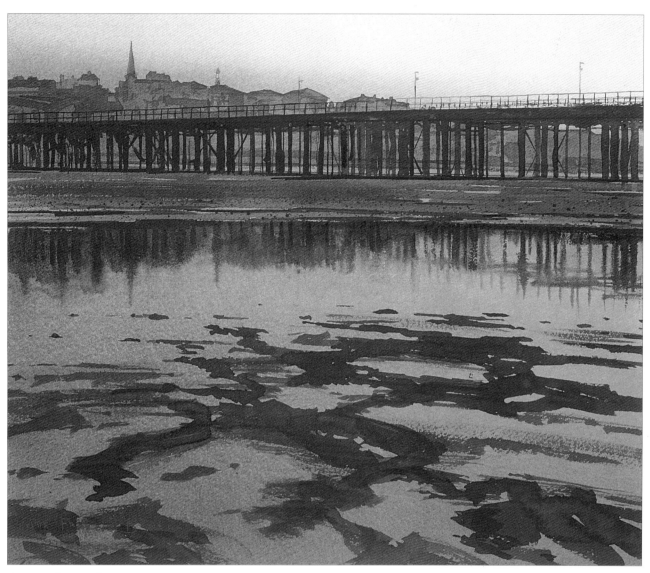

Pier on the Sands

Size: 405 x 345mm (16 x 13½in)

In this nearly-square format painting, Naples yellow was used as a base into which the other colours were worked. The subtle violets are mixes of ultramarine blue, alizarin crimson and burnt sienna. The very soft reflections of the pier were the result of gum arabic being brushed on to the paper before the colours were applied. Diagonal strokes, flattening out with distance, provides foreground perspective.

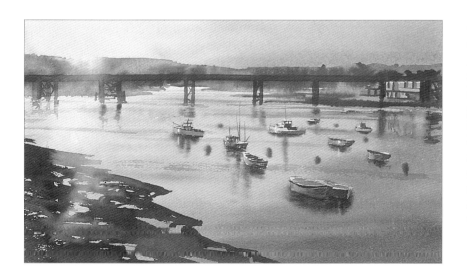

Sunset over Estuary

Size: 405 x 230mm (16 x 9in)

Subtle grey sky washes, fading to nothing in the vicinity of the sun, provide the brightness in this painting. The sun is not painted at all, but we know it is there because its glare is eating into the landscape below, the colours of which change from normal to red to yellow then no colour at all. Water is used to create the loose fluid shape of the glare. It would be different if I did it again, but that would not matter!

Puddles

A few puddles bring this simple scene to life; they add interest to the image and unite the other parts of the composition. The basics for painting puddles are simple. Ensure there is subject matter to be reflected. Work the reflections wet and vertical. Puddles can enhance deep sky reflections, so you can often paint them a slightly darker blue than the sky itself.

Although this is a narrow winding lane, in this composition it is very wide in the foreground where there is just sufficient detail to be convincing. The lane leads the eye into the distance and on to explore the rest of the image. There is hardly any detail in the distant, off-centre focal area, but there does not need to be.

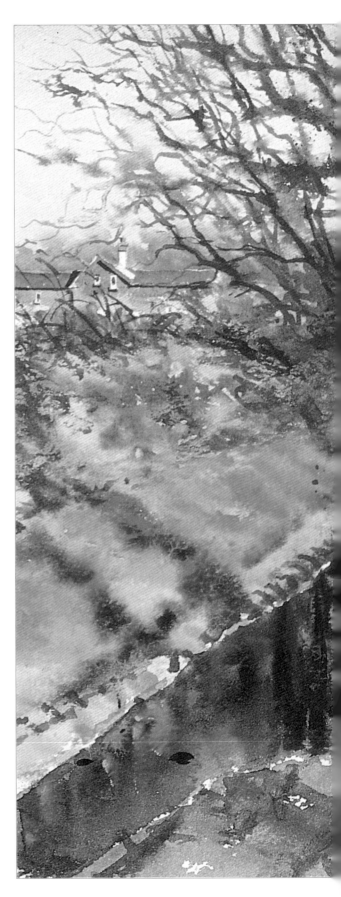

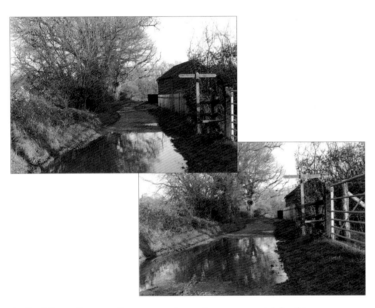

Both of these photographs were used as reference material for this demonstration. Most of the composition is taken from the top photograph, but I added the foreground detail from the other one to raise the horizon line and focal area well above the middle of the image.

Paint all puddles as a single wash, add reflections, then, when these are dry, block in the dry parts of the road.

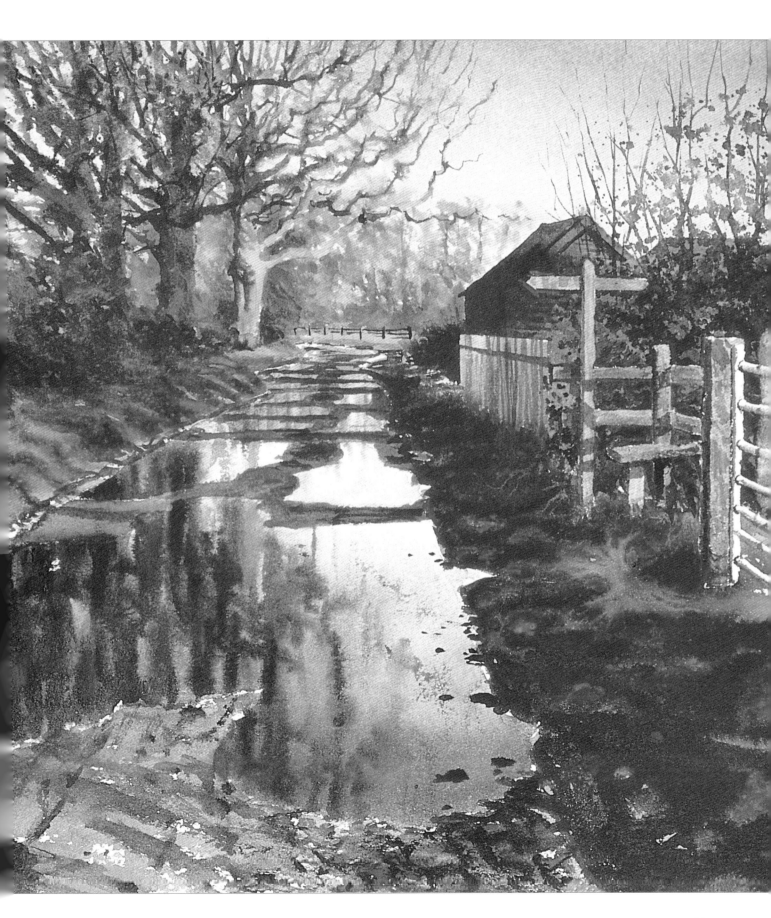

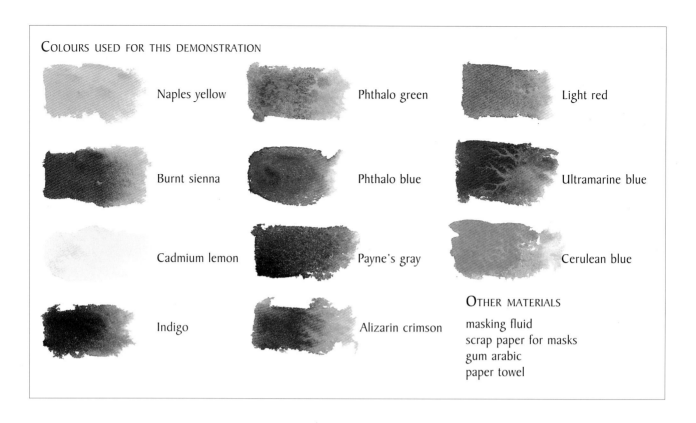

COLOURS USED FOR THIS DEMONSTRATION

Naples yellow

Phthalo green

Light red

Burnt sienna

Phthalo blue

Ultramarine blue

Cadmium lemon

Payne's gray

Cerulean blue

Indigo

Alizarin crimson

OTHER MATERIALS

masking fluid
scrap paper for masks
gum arabic
paper towel

1 Referring to pages 24–25, sketch the composition, make a tracing, then transfer
the basic outlines on to the watercolour paper. In this composition I used
elements from both of the reference photographs on page 34.

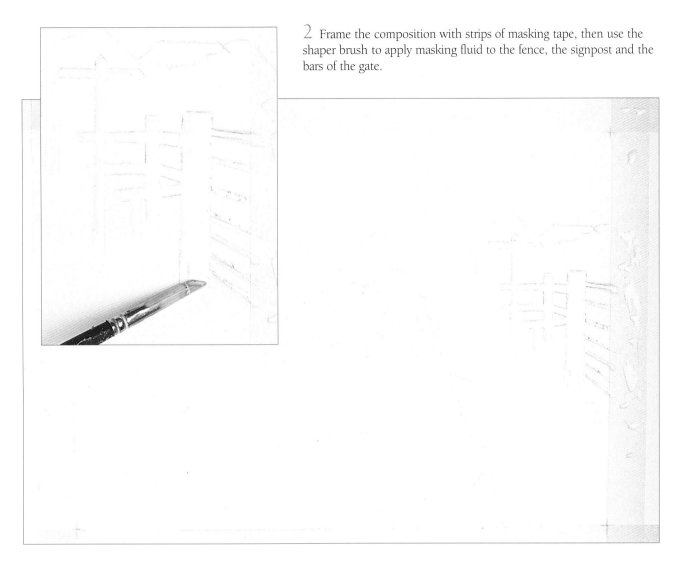

2 Frame the composition with strips of masking tape, then use the shaper brush to apply masking fluid to the fence, the signpost and the bars of the gate.

3 Wet the sky area down to the horizon, but leave the shapes of the buildings on both sides of the paper dry. Lay in a band of Naples yellow, 25mm (1in) up from the horizon, drop in a wash of alizarin crimson along the horizon, then blend this up into the Naples yellow. Soften the bottom edge of the crimson, then dry with a hair dryer.

4 Rewet the sky area as step 3, then, working from the top of the paper, lay in a pale wash of phthalo blue mixed with a touch of phthalo green, weakening the wash as you work down into the yellow and crimson. Brush a darker wash of blue into the top right-hand corner, wet in wet. Soften the bottom edges with clean water.

5 Remove the masking tape from around the painted area and leave to dry slowly.

6 Wet the puddled area of the road, then lay a pale wash of burnt sienna in the middle distance. Now lay a wash of phthalo blue mixed with a touch of indigo, into the foreground, weakening the wash as you work up into the burnt sienna. Tilt the top of the painting board up to allow some colour to fall down in to the foreground. Leave to dry.

7 Using random, crisscross strokes made with the edge of the brush, gently brush (feather) clean water over the area of the foliage at the end of the road. Then, using the point of the brush, apply a mix of Naples yellow with a touch of burnt sienna through the feathered area to form the branches. Use the same mix to block in the foliage round the shapes of the left-hand buildings and the end of the fence at the right-hand side. Leave to dry.

8 Use a mix of light red with a touch of ultramarine blue to work up the darker areas of foliage. Use negative painting to start to define the form of the branches of the large tree. Leave to dry.

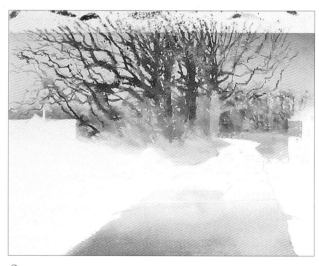

9 Darken the mix with more ultramarine blue, then develop the shapes within the foliage. Use a mix of light red and cerulean blue, and the feathering techniques, to develop the mass of branches. Start with pale tones and gradually darken them as you add finer detail. Leave to dry.

10 Use a wash of Naples yellow mixed with a touch of burnt sienna to block in the bank and hedge at the left-hand side. Add touches of burnt sienna, then blend the colours together. Leave to dry, then use pieces of scrap paper as masks above and below the area of the grassy bank. Spatter a bright green, mixed from cadmium lemon and phthalo green, followed by a darker mix of ultramarine blue and light red, spattered wet into wet. Leave to dry.

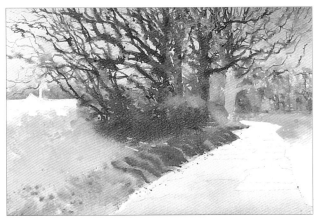

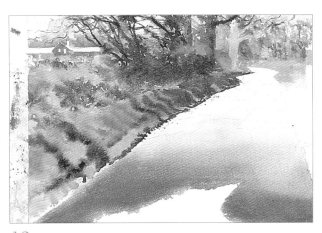

11 Using the feathering technique, wet parts of the grassy bank and hedge then use ultramarine blue mixed with light red and phthalo blue to paint dark green shadows on the bank. For the darker areas of the hedge, use a mix of light red with touches of Naples yellow, merging the colour up into the branches of the trees. Add touches of ultramarine blue, wet in wet, to form deep shadows in the hedge. Use a mix of cadmium lemon and Naples yellow to add highlights to the top of the hedge, then accentuate these with some darker marks.

12 Use the same techniques and colours to work up the rest of the grassy bank and hedge. Use the dark green mix to define the front edge of the grassy bank. Use light red to block in the walls of the building behind the hedge.

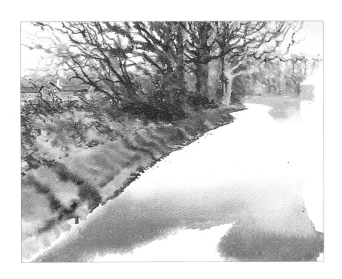

13 Use the dark colours in the palettes to build up detail in the hedge, on the trunks of the larger trees and the shadows on the distant building.

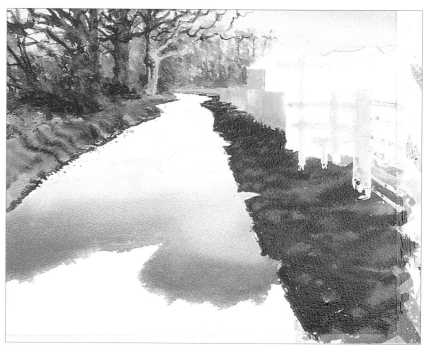

14 Wet the shape of the wooden fence, then, using a mix of Naples yellow with touches of ultramarine blue and light red, block in the fence. Use cadmium lemon with touches of phthalo green to block in the grass bank. Leave to dry.

15 Wet the grass then, using mixes of phthalo green and indigo, brush in the shadowed areas, making the strokes smaller as you work into the distance. Add more indigo to the mix, then make crisscross brush strokes across the paler lines, again making them smaller with distance. Working wet in wet, add patches of cerulean blue and allow all colours to blend together.

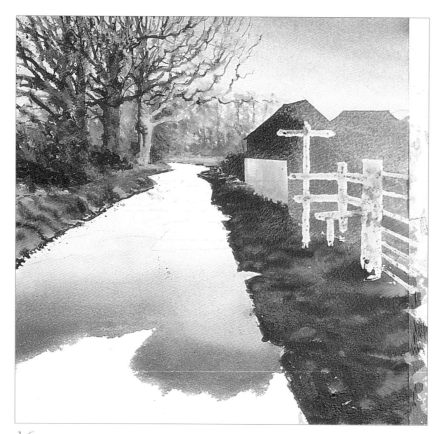

17 Glaze a mix of ultramarine blue and light red over the fence. Spatter clean water over the buildings, then spatter a mix of burnt sienna and indigo for the foliage behind the fence. Mix a touch of light red with indigo, then draw branches through the foliage, wet in wet. Use this mix to deepen the shadows on the roof and wall of the building, to add an indication of a small fence in the far distance and, when the large fence at the side of the buildings is dry, to add detail and shadows to it.

16 Use burnt sienna to block in the buildings behind the fence, then, working wet in wet, add touches of indigo for the dark tones on the sides of the buildings Leave to dry.

18 Wet the road down to the edge of the puddle, leaving a few dry patches in the area of the large tree reflection, then apply a few vertical strokes of gum arabic (see red marks on the diagram below). Working wet in wet, apply Naples yellow and burnt sienna to the distant road, and burnt sienna with touches of light red and Naples yellow to the tree reflection. Brush vertical strokes of Payne's gray into the tree reflection, then streak in touches of Naples yellow and cerulean blue. Leave some light, vertical shapes in the puddle for sky hole reflections.

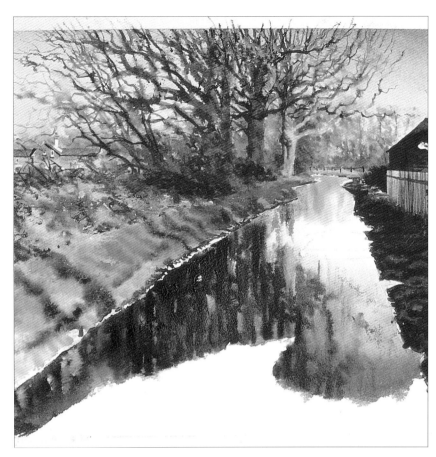

The red marks on this diagram show where I applied gum arabic.

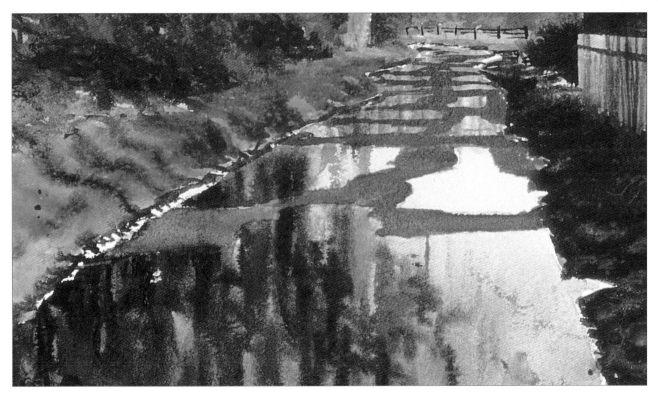

19 Use the original tracing to redefine the puddles, then use a damp brush to lift dark tones out of some of the reflections that should be dry road. Use a mix of cerulean blue and alizarin crimson to block in the dry surface of the road. Mix light red with Naples yellow for the lighter area, greying this down with cerulean blue in places. Use fine horizontal strokes of ultramarine blue to separate the distant puddles.

20 Use a mix of Naples yellow and light red to block in the foreground, leaving some of the white paper showing through as highlights.

21 Using mixes of cerulean blue and ultramarine blue, and large brush strokes, paint in a crisscross of shadows across the foreground area of dry road. Add more ultramarine blue to the mix, then make smaller marks to define the darker shadows.

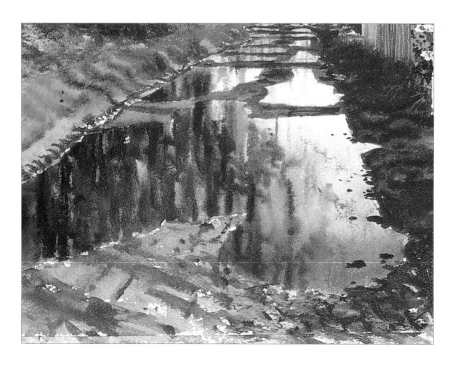

22 Wet the 'white' puddle in the middle distance, lay in a weak wash of phthalo blue, then use Naples yellow to indicate some reflections. Use indigo to add very dark shadows on the dry parts of the road, to define the hard edge of the puddles and to add debris sitting proud of the puddle surface. Make a few random marks in the front right-hand corner of the road.

23 Using a clean wet brush and a piece of paper towel lift out a fence post behind the gate.

24 Pull the masking fluid off the fence posts.

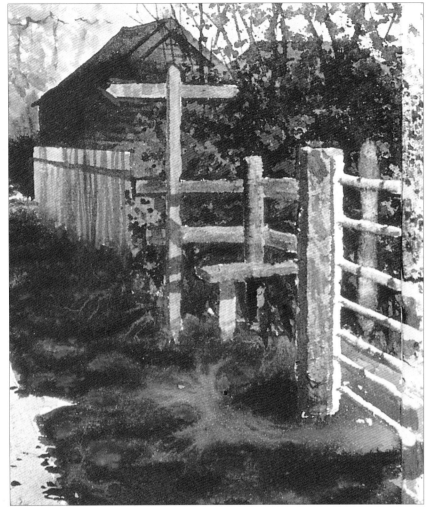

25 Use mixes of burnt sienna and cerulean blue to paint the signpost and fence. Dry them, then use the dark on the palette to define some of the edges. Brush cerulean blue down the side of the end of steel gate. Brush water on to the bars of the gate and add cerulean blue along the bottom edge of each bar.

The finished painting.
At the end of step 25, I stood back to look at the painting and decided to add a few more fine details. I used indigo and ultramarine blue to darken the shadows on the grass at the left-hand side, to add a few more shadows in the foreground and to add more twigs and shadows at the top of the hedge.

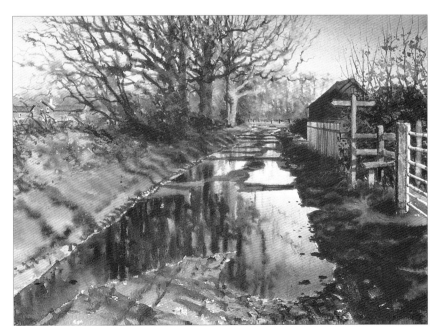

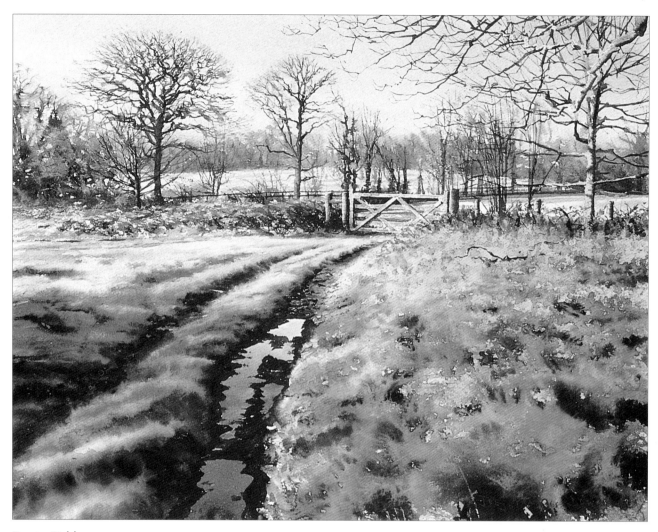

Frosty Fields

Size: 485 x 370mm (19 x 14½in)

In this painting, the track swings from the bottom left-hand corner into the middle; the two equally divided foreground masses may break a few rules, but they work for me. There is no distinct focal point behind the gate, but another field edge and more beyond provides space for the eye to wander. The sky is cerulean blue as is the frosty grass which also has touches of cadmium lemon and darks painted with indigo. The right-hand foreground has cobalt turquoise light brushed wet in wet over oranges mixed from burnt sienna, cadmium lemon and phthalo green. The darks in this area are Payne's gray and indigo. The water feathering technique was used to depict the canopies of the distant trees. All highlights, except the puddles, were masked before any paint was applied to the paper. The puddles were painted with a single wet in wet, upside-down-sky wash of phthalo blue and indigo. When this was dry, the dark shadowed areas around the puddles were painted loose and jagged to define their shapes; large marks in the foreground, getting smaller as they recede.

Opposite above
November Reflections

Size: 430 x 295mm (17 x 11¾in)

The low viewpoint of this composition creates a large expanse of beautiful water out of an ordinary roadside puddle. I started this painting by masking out some leaves in the foreground and a few, vertically elongated sky holes in the puddle. These sky holes needed protection because the reflections in the puddles were worked very wet. Lots of colour was dragged down in a wet water wash, with a little gum arabic added to give a sticky effect. When this dried, a few horizontal lights – shafts of sunlight glancing across the puddle – were lifted out by dragging the point of a damp round brush across the puddle. Finally, the masking fluid was removed to leave the dappled lights from the wooded canopy.

Opposite
Muddy Lane

Size: 380 x 260mm (15 x 10¼in)

This composition consists of two rectangles, a narrow one at the top and a broad one at the bottom, linked by the perspective lines of the lane. Notice how the puddles start as long, deep shapes in the foreground, then gradually reduce to narrow slashes in the middle distance. All the puddles were painted as a single wash of phthalo blue and Payne's gray. When this dried, the tree reflection was brushed in and other marks were made with vertical strokes of a dry brush. When these marks were dry, Payne's gray mixed with a little light red was used to define the shape of each puddle. This scene is a short distance up the lane featured in the previous demonstration and shows how a single location has the potential to yield lots of different subject matter.

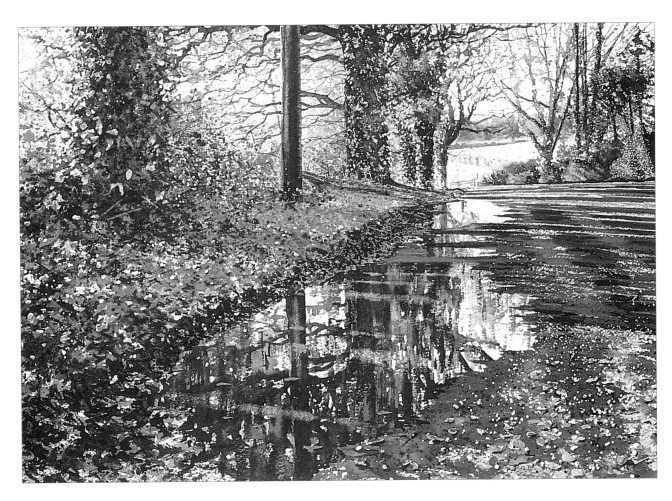

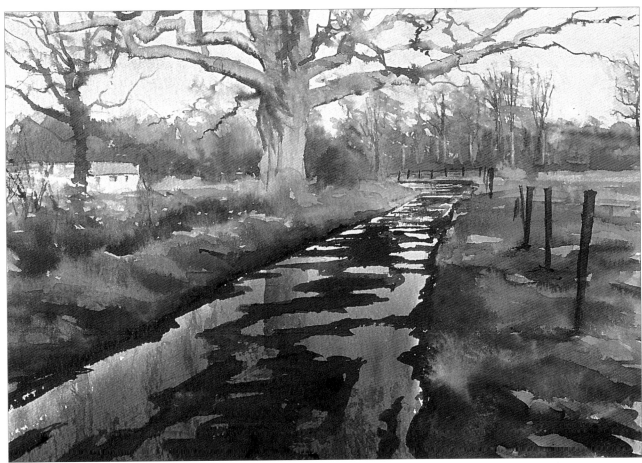

Rippled water

This demonstration includes the characteristics that are typical of river scenes: the type of reflection; the colours reflected on the surface of the water and the shape of the ripples.

Lighter reflections bounce off the surface of water like a mirror. Even on a muddy river, the reflection of the sky can hide the murk below. In the foreground, the colour of the sky reflection is darker than the visible sky because it mirrors the sky high overhead (out of the image area). Further away, as the viewing angle becomes more acute, the colour becomes paler, and can often appear as white.

On the other hand, dark reflections create windows on the surface of the water through which underlying colours can be perceived. The reflections in these areas can take on a brownish tinge because of silt in the water. The viewing angle through these windows affects the visibility of the river bed. Foreground windows, for example, will allow you to see deeper into the water, making reflected colours darker than those further away.

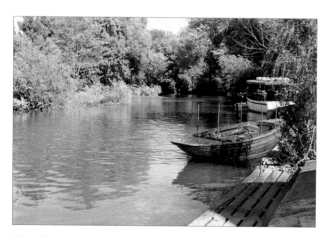

The reference photograph used for this demonstration.

The secret of painting ripples is not to try too hard. Let the ripples flow from the tip of a well-pointed brush, working back and forth in horizontal strokes.

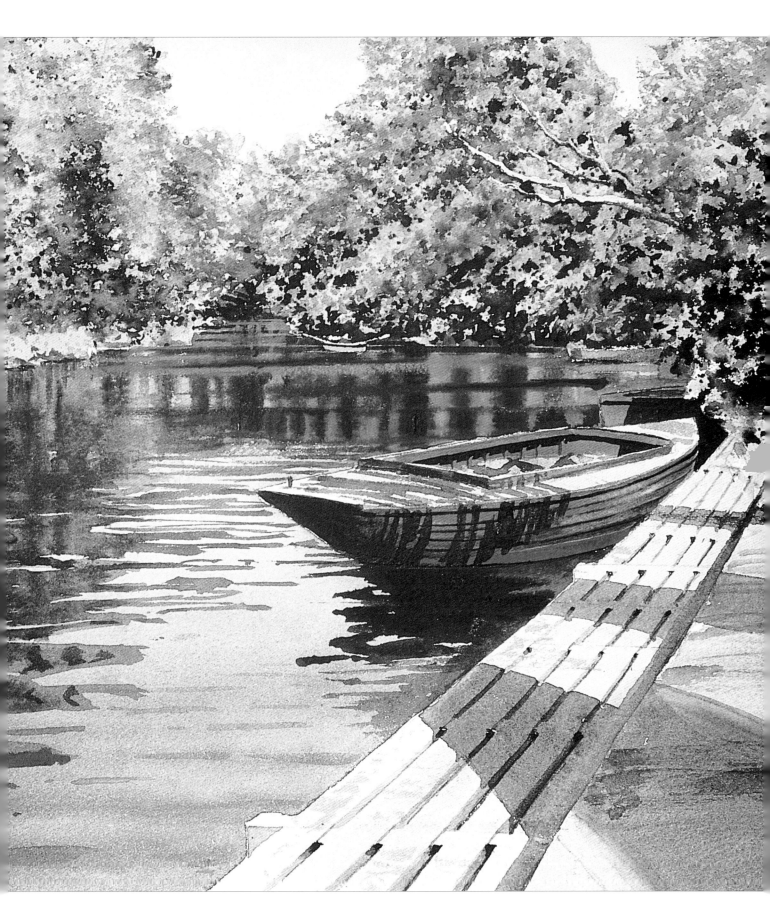

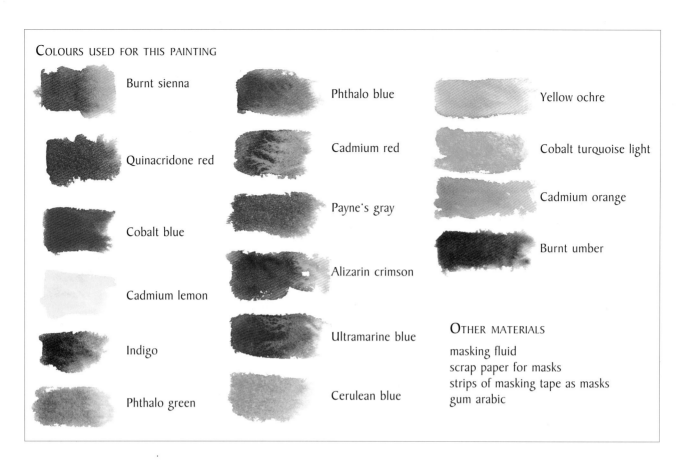

COLOURS USED FOR THIS PAINTING

Burnt sienna

Quinacridone red

Cobalt blue

Cadmium lemon

Indigo

Phthalo green

Phthalo blue

Cadmium red

Payne's gray

Alizarin crimson

Ultramarine blue

Cerulean blue

Yellow ochre

Cobalt turquoise light

Cadmium orange

Burnt umber

OTHER MATERIALS

masking fluid
scrap paper for masks
strips of masking tape as masks
gum arabic

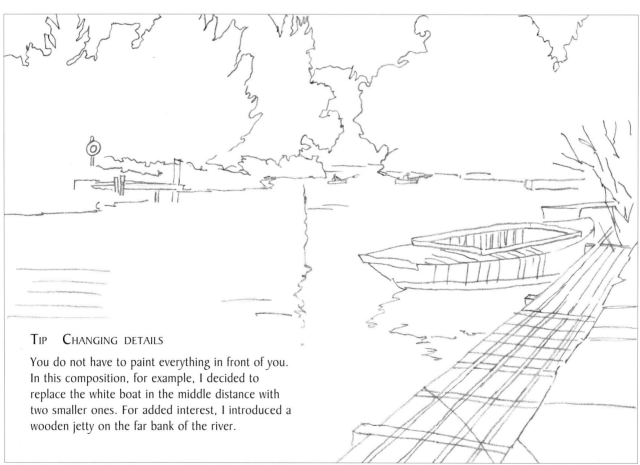

TIP CHANGING DETAILS

You do not have to paint everything in front of you.
In this composition, for example, I decided to
replace the white boat in the middle distance with
two smaller ones. For added interest, I introduced a
wooden jetty on the far bank of the river.

1 Referring to pages 24–25 and the reference photograph on page 46, make a tracing
of the composition, then transfer the basic outlines on to the watercolour paper.

2 Apply strips of masking tape round the edges of the painting, then use masking fluid to block out the jetty on the far bank and the two boats in the distance. Leave to dry.

3 Wet the whole of the sky area, then lay in a wash of cobalt blue mixed with touches of alizarin crimson and burnt sienna, taking this down behind the distant trees and along the far banks of the river. Mix a wash of phthalo blue with a touch of phthalo green, then lay in a thin band of this colour along the top of the sky; make the sky darker in the top left-hand corner, and allow this blue to blend with the cobalt blue mix. Remove the masking tape from the wet edges and dry with a hair dryer.

Note At the end of step 3, I spent some time considering how to paint the backdrop of foliage. I decided to mask out a few tree trunks behind the jetty and some branches in the trees at the right-hand side before starting to paint the foliage (see steps 4 and 5).

4 Prepare three washes: one from burnt sienna, cadmium lemon and a touch of phthalo green; the second from just burnt sienna and cadmium lemon; and a third from cadmium lemon with just touches of burnt sienna and phthalo green. Lay in the first wash along the bottom of the left-hand group of trees. Lay the second wash into the trees above, working a dry brush technique at the top where the tree line meets the sky. Introduce touches of the first wash at the right-hand side.

5 Use the third wash to block in the right-hand group of trees and those in the far distance. Add a touch more phthalo green to this wash, then block in the foreground foliage at the right-hand side.

6 Use torn pieces of paper to mask the patches of the sky and all the water, then spatter clean water all over the trees. Add ultramarine blue to the previous washes then spatter these randomly over the trees to start building up texture.

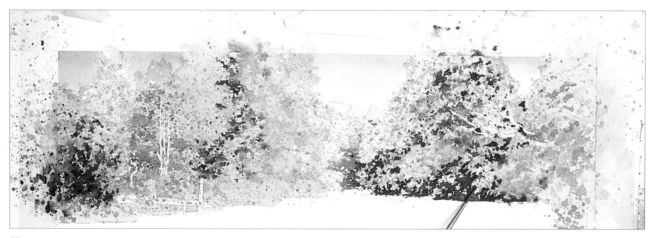

7 Build up the foliage with successive layers of spattered colour on spattered water. Dry the paper after each layer, and gradually make the tones darker and the spatters smaller. Fold back the paper masks, then use Payne's gray and the tip of a brush to model the canopies of foliage. Define their edges with areas of shadow and model the right-hand river bank.

8 Spatter water over the distant woodland in the centre of the composition, then apply cerulean blue with the point of a brush to create shadowed areas in the trees.

9 Continue building up shape and form by spattering more layers of colour and using the brush to enlarge some of the speckles. Add more paper masks as necessary. Brush touches of cerulean blue and cadmium lemon into the darks as highlights.

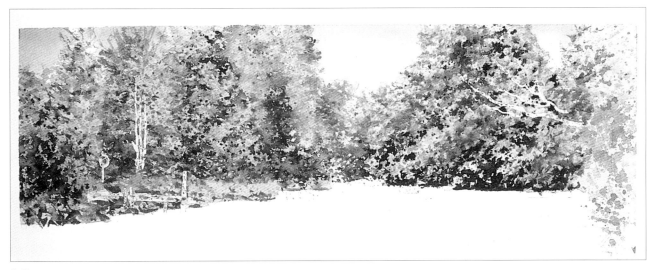

10 Complete the backdrop by tidying up the far bank, remove all masks and masking tape, then leave to dry.

11 Replace the masking tape. Wet the river, stopping short of the river bank and cutting round the boat shapes and foreground staging. Mix phthalo blue with touches of quinacridone red and indigo, then wash this in from the bottom upwards, saving a lot of light further up in the river. Take the wash up to the edge of the saved-white areas. Darken the bottom left-hand corner bottom of the river.

12 While the colour is still wet, brush in a few horizontal strokes of indigo in the foreground stretch of water to represent the underlying soft ripples in the water. Remove the masking tape borders and allow colour at the edges to bleed back into the river from the wet edges. Leave to dry

13 Paint the wooden staging, wet on dry, with a mix of burnt sienna, cerulean blue and a touch of yellow ochre. Add more blue to the mix and block in the concrete path. Use a weak wash of neat cerulean blue to add texture to the concrete. Leave this to dry naturally so that the blue granulates. Paint the boat with burnt sienna, leaving a strip at the water line, the deck and the bottom of the inside of the boat white. Use the same colour to paint the small boat moored behind the large one.

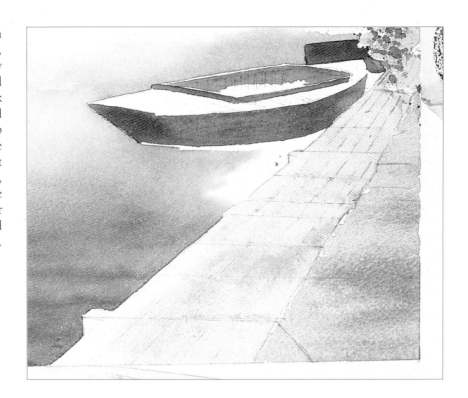

14 Using a mix of ultramarine blue and burnt sienna, paint the shadows on the staging and concrete path wet on dry. Note how these shadows dip between the boards of the wooden staging. Dry the painting, then stick thin strips of masking tape across the boards of the staging. Make the strips slightly narrower and closer together as they get further away.

15 Using a weak wash of burnt sienna and a fine brush, paint the gaps between the boards. Darken these with ultramarine blue in the shadowed areas. Make small marks of indigo in the areas of cast shadows. Dry the painting, then gently remove the strips of masking tape. Paint fine lines along the top edges of the boards in these exposed areas.

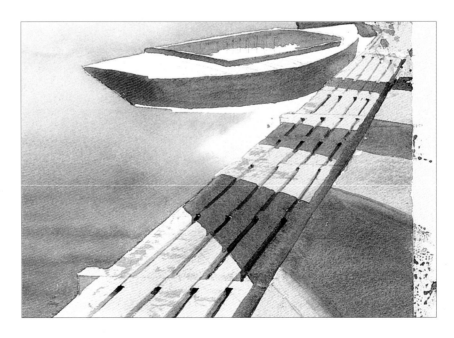

16 Use mixes of cadmium lemon and burnt sienna to give a three-dimensional shape to the hull. When this is dry, brush fine lines of ultramarine blue mixed with burnt sienna, to define the planks on the hull. Dry the painting, then paint a strip of cadmium red along the bottom of the hull. Mix a very light grey wash of ultramarine blue and burnt sienna, then block in top of the boat. Use a light yellow-green from the palette to paint the tarpaulin in bottom of the boat. Dry these colours, then use indigo to paint a thin shadow at the water line, the shadow at the stern, the cast shadows across the boat and the dark detail inside the boat.

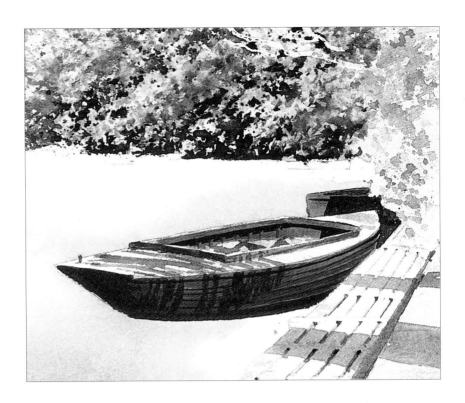

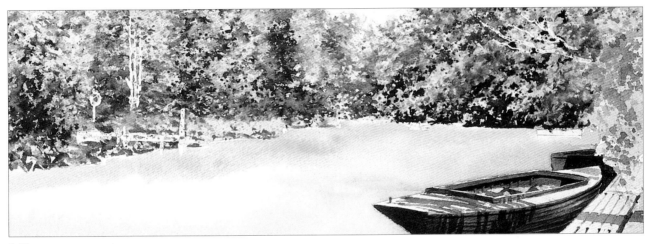

17 Rewet the distant water, then drop in a base wash of cadmium lemon mixed with burnt sienna for the soft reflections of the background trees.

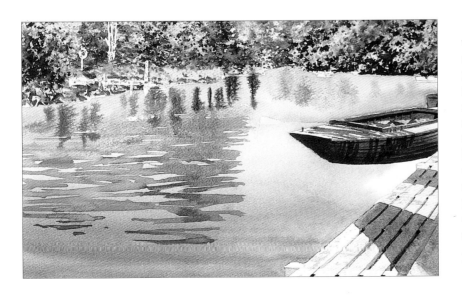

18 While the previous wash is still wet, use mixes of burnt umber and cadmium lemon, with touches of phthalo green, and horizontal brush strokes to work the hard-edged reflections, making the strokes bolder and more open as you work downwards. Gradually introduce more burnt umber and touches of ultramarine blue as the marks get closer. While the colours are still wet, paint a little gum arabic into the area of cadmium lemon (see page 41), then add vertical strokes of Payne's gray as reflections of the dark areas in the background foliage.

19 Continue to build up the reflections with vertical bands of Naples yellow and cadmium lemon between the Payne's gray ones, and with phthalo green behind the boat. Pull the colours down into the still-wet horizontal ripples, without disturbing their shapes. Make the strokes thinner in the distance.

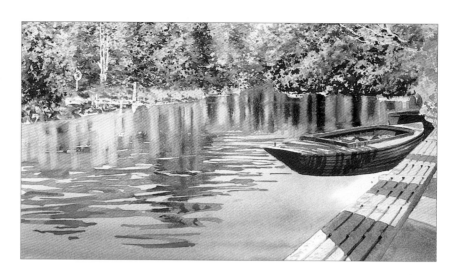

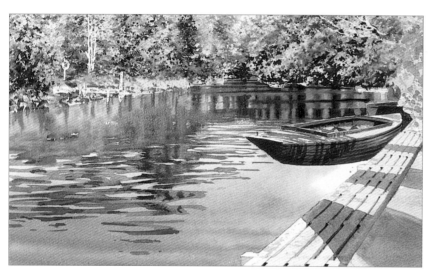

20 Lay in a few horizontal strokes of cobalt turquoise on the distant water, then darken the closer ones of these with Payne's gray. Use vertical marks of cadmium lemon to create highlights against the deep shadows, then add touches of burnt umber. Use a clean brush to soften and merge the colours in the distant water. Add darks to the now dry foreground ripples.

21 Using burnt umber and Payne's gray, work up the reflections in front of the boat.

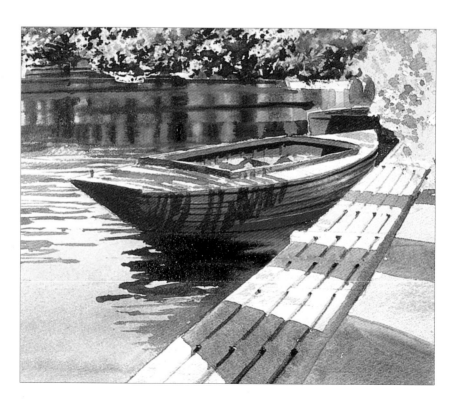

22 Mix a weak wash of cobalt blue with burnt sienna, then add touches of this to the soft foreground ripples to key these into the other reflections. Add touches of indigo and burnt sienna to the concrete path. Spatter more darks in the foreground foliage, then use a fine brush to link some of the spatters together to form dark shadows. Dry all the colours, then remove the masking fluid.

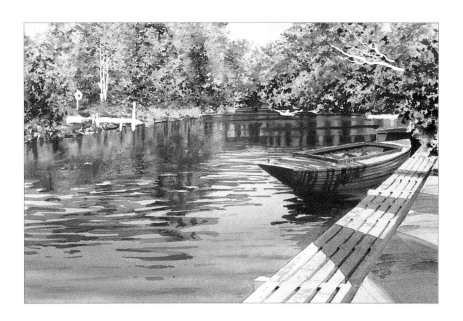

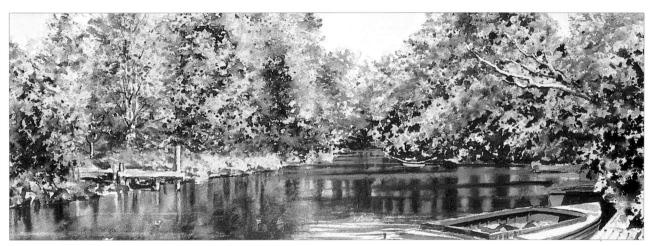

23 Finally, add the fine details. Paint the life belt using a mix of cadmium orange and cadmium red. Use burnt sienna and darks from the palette to paint the bare branches, adding touches of indigo on their undersides. Work broken strokes of browns, greens and indigo across the tree trunks on the far bank. Block in the far right-hand boat with burnt sienna. Use cadmium lemon for the distant boat with a touch of cadmium red for the rower. Lift out the reflections of the jetty, then use tones of burnt sienna and cadmium lemon, and darks from the palette to complete the jetty.

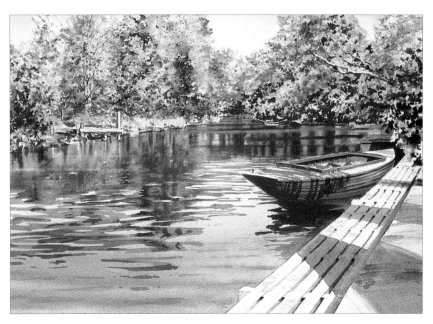

The finished painting

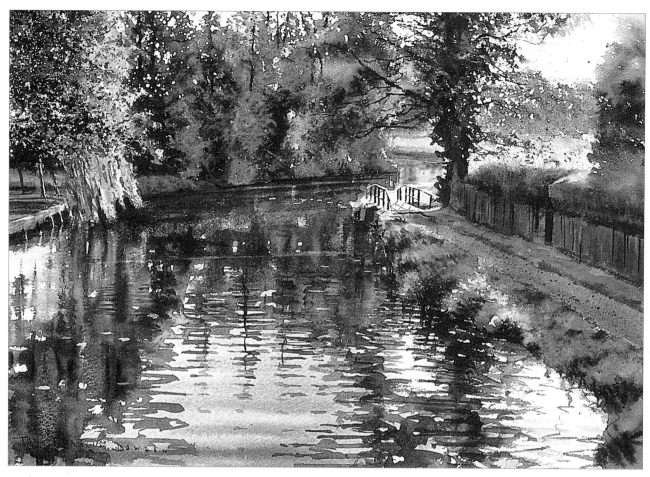

Sunlit Navigation

Size: 430 x 295mm (17 x 11¾in)

A wash of phthalo blue and indigo was used to paint the reflected sky. When this initial wash was dry, a large quantity of water was brushed on to the upper part of the river, then indigo, phthalo green, and cadmium lemon were run into this and allowed to blend. The ripples were dragged out of the wet area on to the dry paper below, making them larger in the foreground. These were kept wet and colourful with the addition of cadmium lemon and burnt sienna.

Opposite above
Waterborne
Size: 380 x 265mm (15 x 10½in)

The deep ripples left in the wake of the barge cut right across the river, so it was necessary to leave out long streaks, saving whites or the underlying colour, to produce these long light ripples. The negative sides of dark ripples were painted across the sky reflection. Notice how the lights and darks interconnect to make the surface pattern. A little masking was done around the barge, and the exhaust cloud was blurred by letting the dark colour into a clean water wash at that point. Masking fluid, spattered from a toothbrush, was used to produce the sky holes in the trees.

Opposite
December's Foggy Breath
Size: 305 x 210mm (12 x 8¼in)

In this winter scene, the snow was painted with light washes of cerulean blue and quinacridone red. These colours were also used in the reflection colours in the water. Long vertical marks are blurred in the mass of reflection by working them wet in wet, but, where they emerge on to the sky reflection, they are painted wet on dry. The angled lines of diagonal reflections are stepped, with short vertical segments followed by horizontal ones, to give them a wet rippled feel.

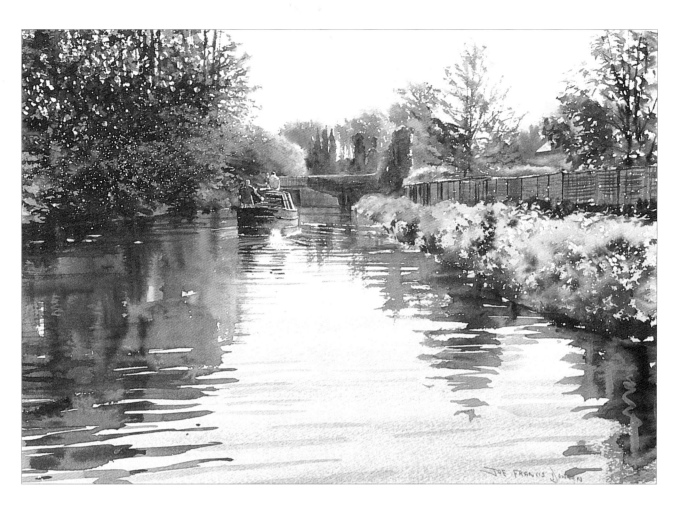

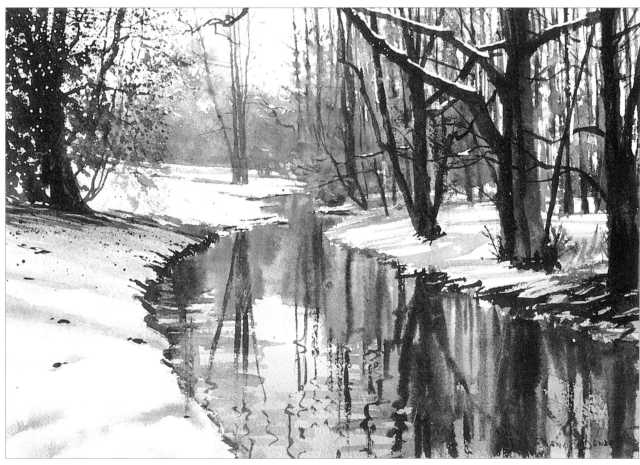

Seascape

I love painting seascapes such as this, where endless ranks of waves roll ashore to break on a rocky coastline. The movement in the water contrasts dramatically with the solidity of the rocks and cliffs. Light is diffused throughout the sea and there are no distinct reflections.

Strong tones, built up with a series of light and dark glazes, provide the contrast between the subdued colours of the banks of clouds, the bright whites of the foam, and the sunlit mass of rocks. The water is defined by the colour it takes from the sky, and the shapes of the ocean swells that are rendered by simple strokes of the brush.

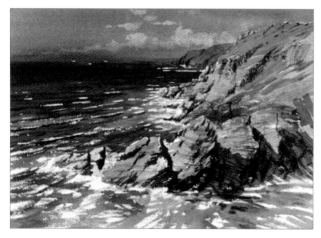

This colour sketch, painted in situ, was used as the reference material for this demonstration.

Build up tone and brush marks with a series of glazes. Saved whites add detail to this rocky coastal scene.

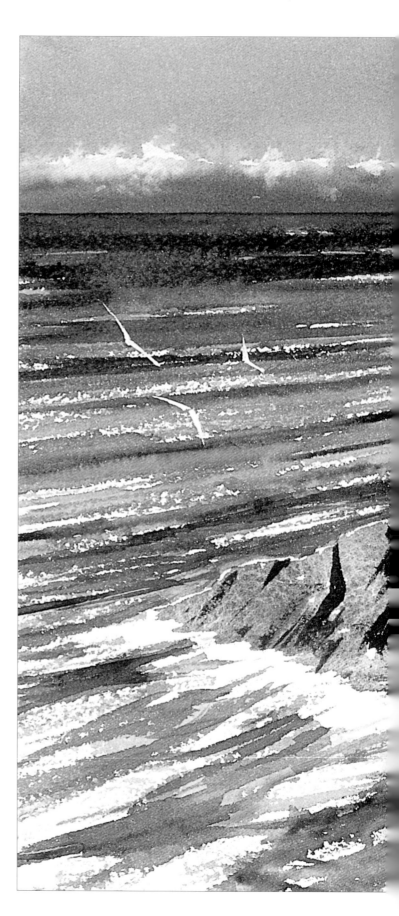

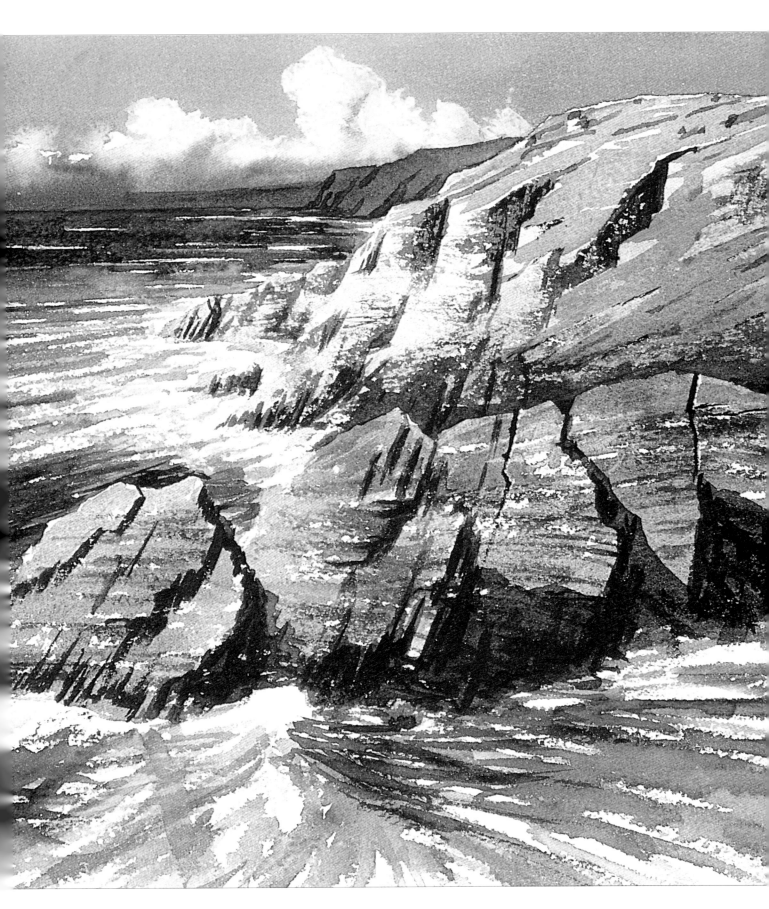

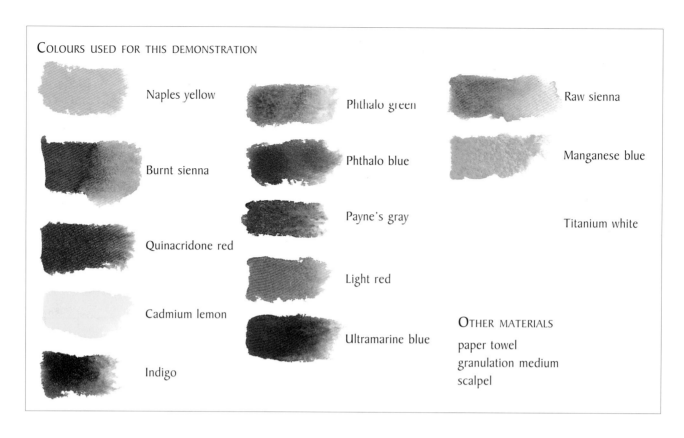

COLOURS USED FOR THIS DEMONSTRATION

Naples yellow

Phthalo green

Raw sienna

Burnt sienna

Phthalo blue

Manganese blue

Quinacridone red

Payne's gray

Titanium white

Cadmium lemon

Light red

OTHER MATERIALS
paper towel
granulation medium
scalpel

Indigo

Ultramarine blue

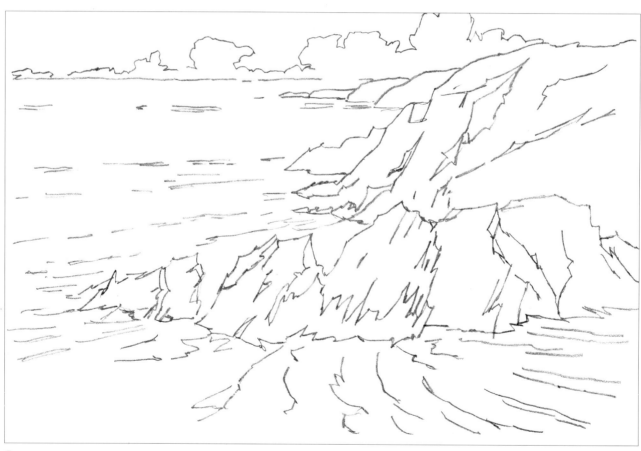

1 Referring to pages 24–25, use the reference sketch on page 58 to make a tracing of the composition, then transfer the basic outline on to the watercolour paper.

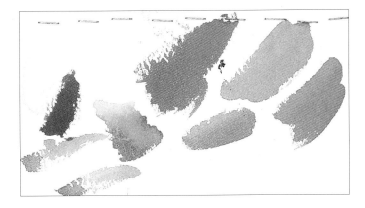

TIP BLUES FOR SKY AND WATER

I have several blues in my palette because each is unique and cannot be duplicated by mixing. I often use several blues in a sky, and I even add a little green. Building different blues into a sky or water wash can give it a vibrancy and make it seem almost iridescent.

I invariably paint on oversize sheets of paper, so I can use the outer borders to try out different colours before using them on the painting.

2 Wet the sky area and the distant headlands. Lay in a wash of Naples yellow from halfway down the sky to the horizon line. Then, while the yellow is still wet, add a wash of quinacridone red along the horizon, taking it over the distant headland but leaving a dry edge along the top of the nearer headland. Leave to dry.

3 Rewet all the sky and the distant headland and wet all the sea, leaving some thin horizontal streaks of dry paper in the most distant part for the foaming crests of waves. Mix a wash of phthalo blue with a touch of phthalo green, then paint in the sky, cutting round the shape of the cliffs. Bring this colour down into the distant area of sea, leaving some white streaks.

4 Working wet in wet, paint the sea area behind the foremost rocks, leaving the dry white streaks and diluting the colour as you work downwards.

5 Use ultramarine blue to define the horizon, wet in wet, blending it into the sky and sea. While this colour is still damp, dab out some clouds with scrunched up pieces of paper towel. Use a clean part of the paper for each dab.

6 Use clean water to soften the bottom edges of the clouds. Brush in diluted ultramarine blue to create shadows under the clouds. Bring down some of the top sky colour to add shape and form to the clouds.

7 Use phthalo blue, mixed with a touch of phthalo green to re-establish the horizon.

8 Use a clean damp brush to soften the bottom edge of the horizon, then work the colour on the brush downwards to darken the distant area of sea, saving the whites of the waves.

9 Overpaint the distant water with indigo, narrowing the distant white streaks of dry paper.

10 Using phthalo blue wet on dry, delicately pick out the wave pattern in the middle distance. Apply horizontal streaks of indigo, wet into damp, to create shadows in the waves. Use phthalo blue and negative painting to define the top edges of the rocks in the foreground. Add streaks of cadmium lemon in the middle distant stretch of water and touches of raw sienna close to the foreground rocks.

11 Start to develop the foreground waves with crisscross strokes of phthalo blue. Then, using different mixes of ultramarine blue, light red, burnt sienna and cadmium lemon, apply more random strokes of colour. Try to build up the impression of movement in the foreground water. Leave to dry.

12 Darken the bottom right-hand corner with touches of indigo and ultramarine blue, then dry thoroughly with a hair dryer. Use indigo, phthalo blue and light red to mix different greys, then develop the movement of the foreground water, adding dark tones on the right-hand side of the swelling waves.

13 Use indigo and phthalo blue to darken the sea behind the foreground rocks. Use negative painting to help define the hard edges of these rocks.

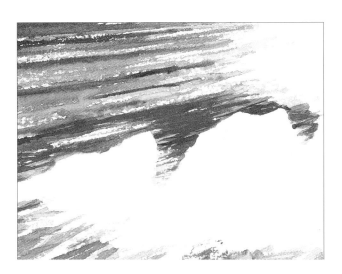

14 Use ultramarine blue and burnt sienna to mix a neutral grey. Add more ultramarine blue this mix to make cool greys, and touches of quinacridone red to make warm greys.

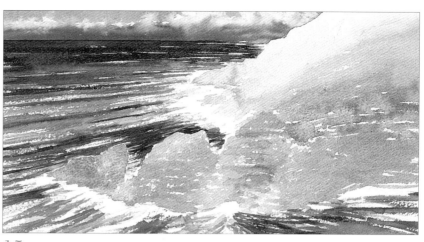

15 Use touches of granulation medium (instead of water) to dilute the grey mixes on the palette, then block in the foreground rocks leaving a fine white highlight round the top edges. Soften the colours at the top of the far part of the cliffs by diluting the greys with water. Leave to dry slowly, enhancing granulation effect.

This full-size view of the left-hand rock clearly shows the pigment granulation.

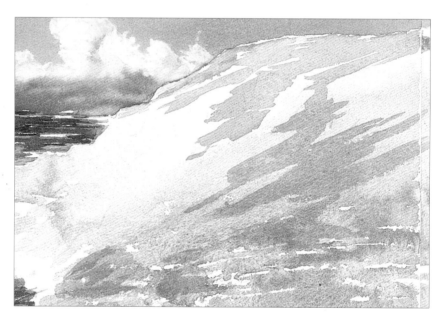

16 Use burnt sienna, manganese blue and cadmium lemon to mix a dull yellowy-green, then block in the grassy areas on top of the rocks and cliffs.

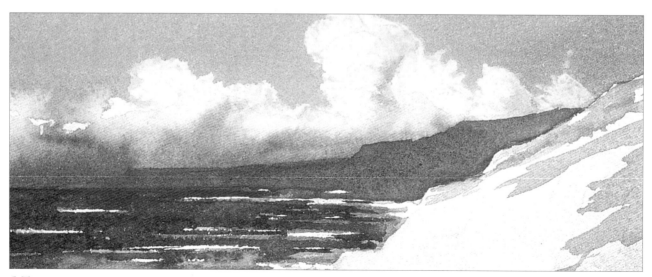

17 Wet the distant headland, add more quinacridone red to the greys on the palette, then paint the far distant headland. Soften the top edge with a clean brush, then leave to dry.

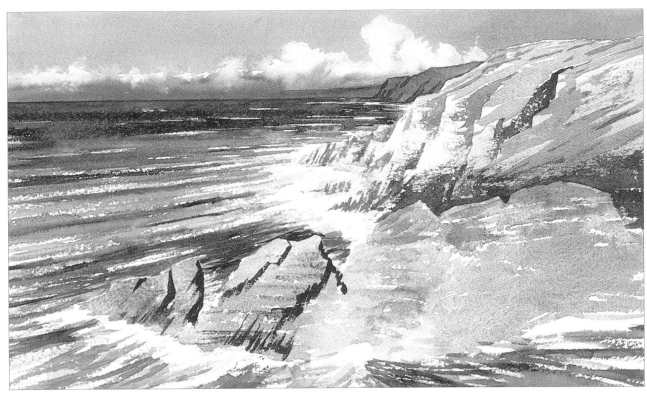

18 Mix some grey with ultramarine blue and burnt sienna, then, working from top to bottom, add the mid-tone shadows to the rocks and cliffs. Paint wet on dry to define edges, then use a dry brush to create texture and form. Darken the mixes as you move down the paper.

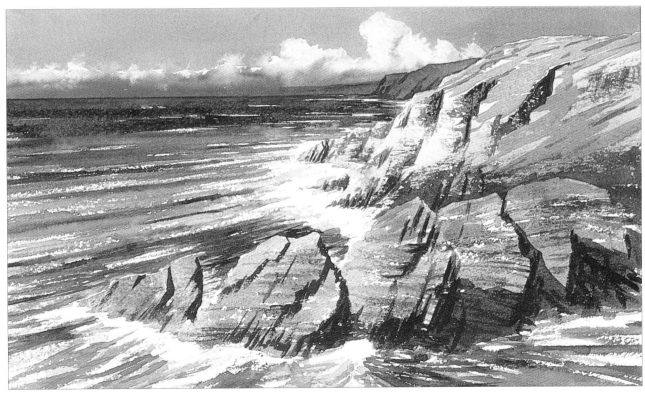

19 When you are happy with the mid-tone shadows, use Payne's gray mixed with a touch of phthalo blue to paint in the dark shadows. Work from top to bottom again, making the foreground shadows darker and more detailed than those in the distance.

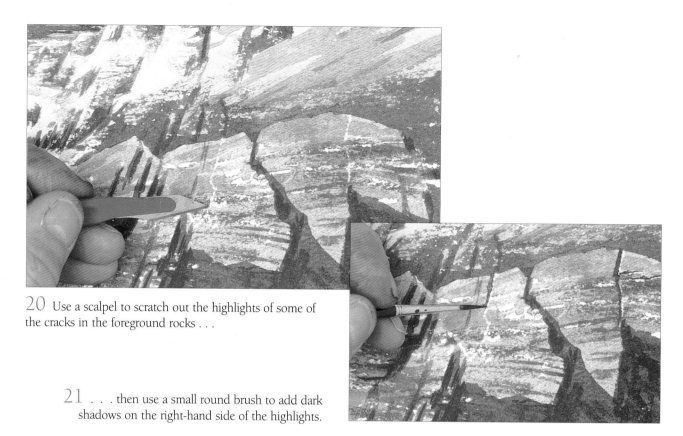

20 Use a scalpel to scratch out the highlights of some of the cracks in the foreground rocks . . .

21 . . . then use a small round brush to add dark shadows on the right-hand side of the highlights.

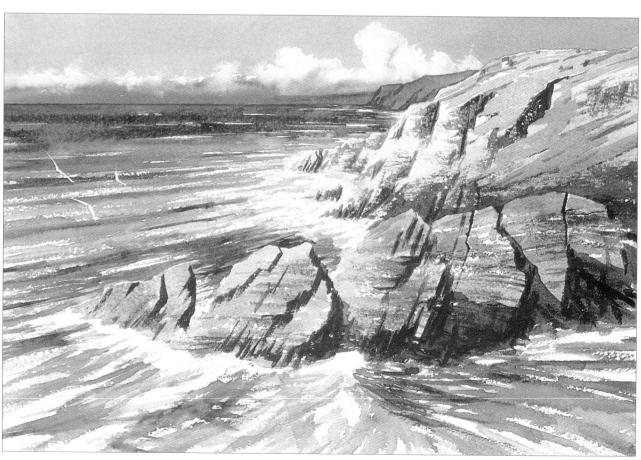

The finished painting. At the end of step 21, I decided to add a few details to the shadows and to the sea beyond the foreground rocks. I also decided to add three swooping gulls which I painted with opaque, titanium white.

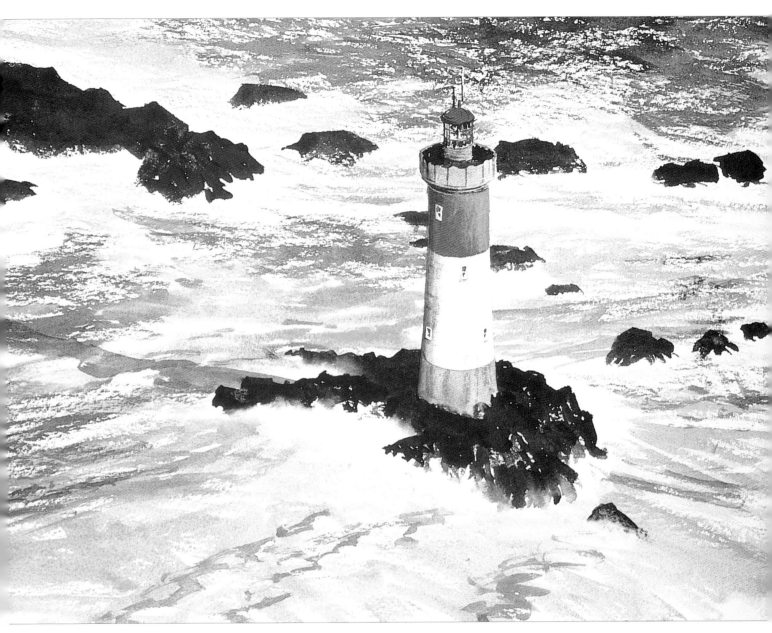

Guardian

Size: 560 x 405mm (22 x 16in)

I started this painting by masking out the lighthouse and dragging the sea colours rapidly across the whole expanse of paper working brush strokes wet on dry, with quite a bit of dry-brush work. Light tones of manganese blue, mixed with touches of quinacridone red and Naples yellow, were used to create the acres of foaming water being dragged across the shoals. Darker tones of this colour mixed with Payne's gray were used in places. Whites were saved around the area of each rock before these were painted with an intense Payne's gray, which was let into water brushed on the paper around their lower edges to get the soft focus spray effect of the sea. Some remaining hard edges were softened with a small flat bristle brush.

When the masking fluid was removed, a wash of cadmium red light was let into a band of water around the top part of the lighthouse, then this was darkened down the left-hand side with ultramarine blue and burnt sienna. Warm grey mixes of these two colours were used for the browns on the veranda and the base of the structure.

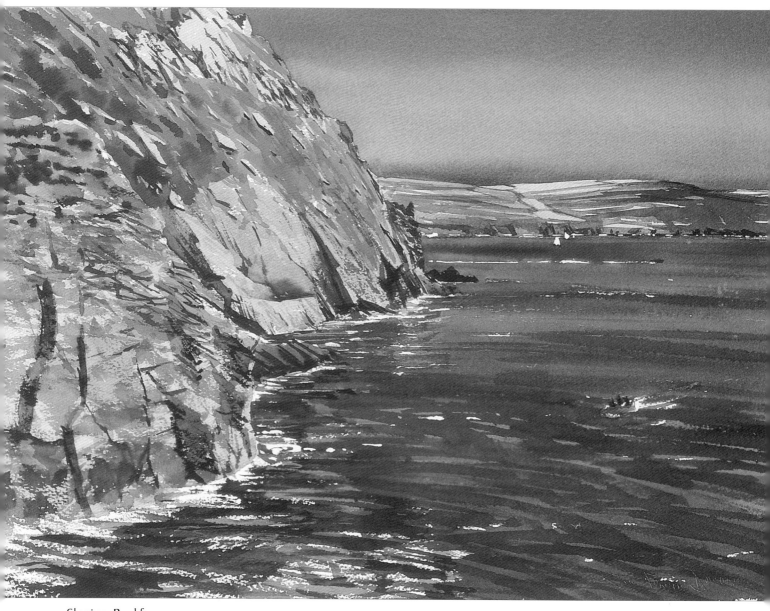

Sloping Rockface

Size: 485 x 345mm (19 x 13½in)

The three images on these two pages were painted in situ within a short distance of each other. For this composition, I laid initial washes of red and orange in the sky, then, when these were dry, I painted the sea and sky with washes of phthalo blue, avoiding the cliff face and distant hills, and saving whites for the foam and the red boat. While the sky was still wet, I added some ultramarine blue into the lower sky. When the sea was dry, I darkened it with a glaze mixed from indigo and phthalo blue, and brushed dark streaks across the wet wash, all the time saving whites.

I painted the cliffs with grey glazes mixed from burnt sienna and cobalt blue. I washed in the distant hills with Naples yellow, then followed this with washes of ultramarine blue and burnt sienna.

I touched in the boat with cadmium red, then used the tip of a knife to scratch out its wake.

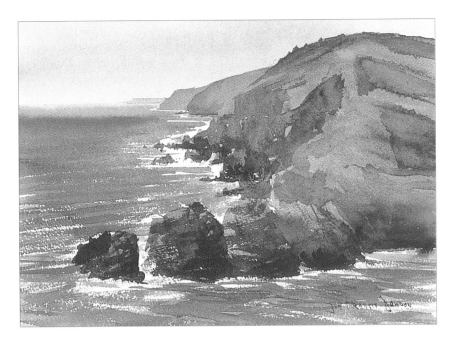

Jagged Rocks

Size: 355 x 255mm (14 x 10in)

This scene is the same subject as the seascape demonstration, but from a slightly different viewpoint, later in the day when the tide was higher. Painted more or less straight into the sun, the whole of this scene was silhouetted, with very dark foreground objects, and distant ones getting paler. This made it easier to paint, with no saving of whites or lights necessary except for the foam. The sky and sea were painted as one, then the sea was darkened with subsequent washes. I added a touch of phthalo green to phthalo blue for the sky colour. As with the demonstration painting, rhythmic brush work describes the movement of the sea.

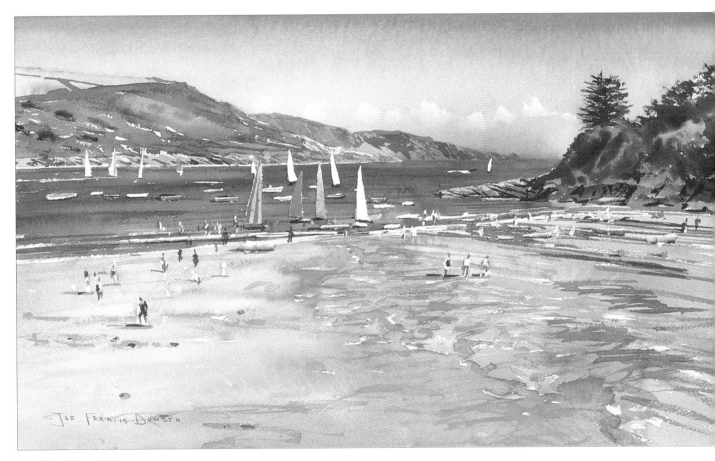

Beach at Low Tide

Size: 405 x 240mm (16 x 9½in)

The groundwork for many watercolour paintings consists of colour washes. Here, I used swathes of water with added colour. The sky and sea were painted as one with phthalo blue mixed with a little phthalo green. The beach is burnt sienna and yellow ochre, greyed with touches of cobalt blue. Whites were saved at the start. The sky has enough tone to make the fields above the distant headland look light in comparison. The sea is darker than the sky. A pattern of light/dark/light was planned at the outset to capture the brightness of this sunny day. Light conditions can change completely during the progress of a painting so it helps to make a lighting plan at the start and fix it in your mind.

Shallow water

Underwater objects, seen from above the surface, make a desirable subject to paint, but painting them is often regarded as an elusive skill. In this demonstration, I show you how to paint see-through water with stones 'swimming' just below the surface. The secret is not to try to paint the water on top of them, but to recreate the special effect that light has on such shallow water. Capture this effect and it will look as if water is there.

Gently lifting the rocks through a glaze gives them a slightly soft, out-of-focus appearance and makes them three dimensional. Water refracts and bends light, and this distortion makes underwater objects appear elongated in the horizontal plane. The deep brown of burnt sienna captures the basic colour, and a few dark marks, brushed in around the lifted-out shapes, completes the effect.

Elements from both of these photographs were used for this demonstration.

Paint the underlying colours of the water, then lift out the shapes of the submerged rocks.

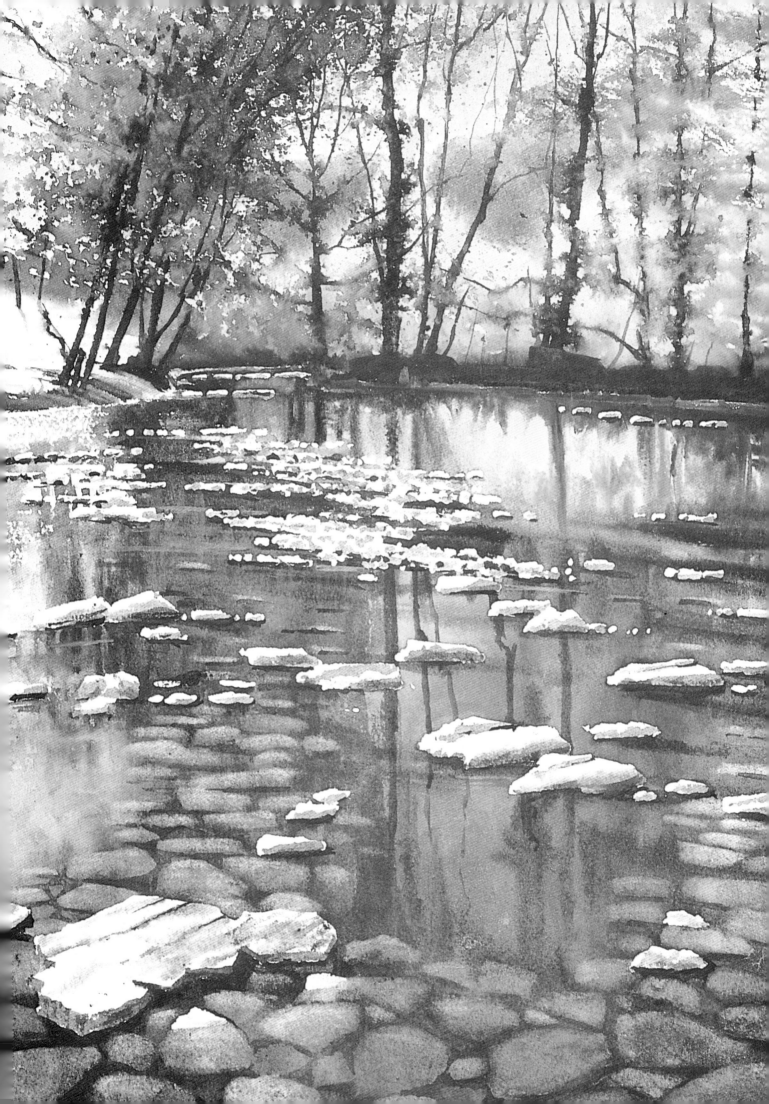

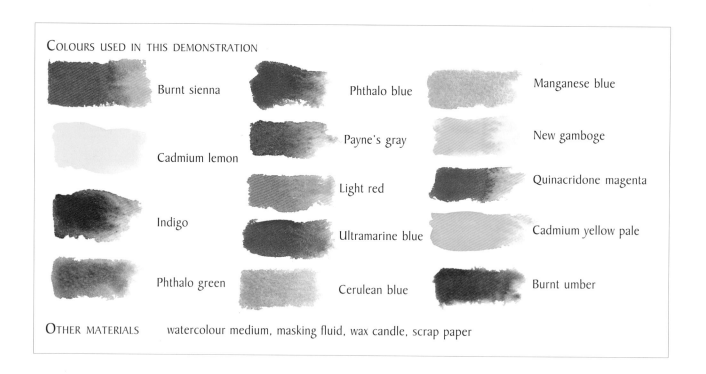

Burnt sienna

Phthalo blue

Manganese blue

Cadmium lemon

Payne's gray

New gamboge

Indigo

Light red

Quinacridone magenta

Ultramarine blue

Cadmium yellow pale

Phthalo green

Cerulean blue

Burnt umber

OTHER MATERIALS watercolour medium, masking fluid, wax candle, scrap paper

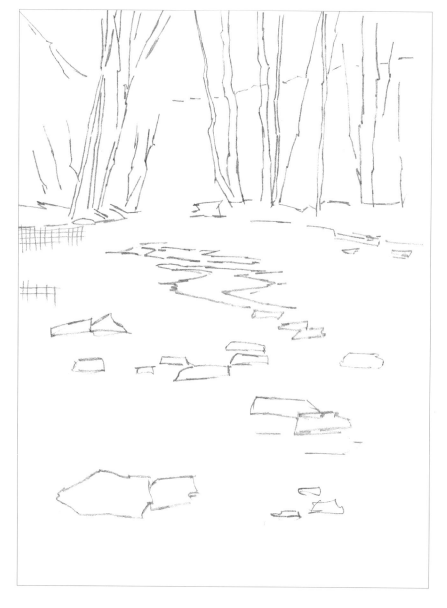

TIP WAX RESISTS

When a wax candle is rubbed gently across watercolour paper, small particles of wax are deposited on the high points or tooth of the paper, but not in the tiny dips in the surface. Wax resists water, so, when a colour is subsequently painted over it, a fine textured pattern of broken white is created. The technique can be used to depict sun sparkling on water, as in this demonstration, for the texture of masonry or to depict small leaves.

1 Referring to pages 24–25, use the reference photographs on page 70 to create the composition, make a tracing and transfer the basic outlines on to the watercolour paper. The red marks on this sketch are those made with the candle in step 3.

2 Apply masking fluid to all the parts of the rocks that sit proud of the surface of the water.

3 Using a wax candle and the straight edge of a piece of scrap paper as a guide, make some horizontal and vertical strokes on the left-hand distant stretch of water (see sketch opposite).

4 Wet the sky area behind the trees and its reflection in the water, then lay in a wash of phthalo blue mixed with a touch of phthalo green. Soften the outer edges with clean water.

5 Now drop in touches of phthalo blue below this reflection and a touch of quinacridone magenta at the bottom of the paper. Mix a touch of phthalo green to the phthalo blue, lay in a weak wash of this colour at the left-hand side of the painting, then leave to dry.

73

6 Wet the background then block in the foliage. Use cadmium yellow pale for the left-hand and central parts of the foliage and cadmium lemon for the right-hand part. Take the cadmium lemon across the bottom of the whole of the background, following the line of the banks of the stream.

7 Wet the area of the distant hills then lay in blue wash of phthalo blue, phthalo green and quinacridone magenta. Drop in touches of orange mixed from cadmium yellow pale and quinacridone magenta. Add more cadmium yellow pale below the hill and across the central and right-hand areas of foliage. Leave to dry, allowing the colours to blend into each other.

8 Mix phthalo green with cadmium lemon, then, with pieces of scrap paper as masks, use the spattering technique (see page 50) to start adding detail to the foliage. Remember to spatter clean water and then colour. Spatter more water to spread the colours, then use a No. 3 round brush to draw some of the spatters into larger shapes. Feather water across the rest of the background then start to lay in a mix of phthalo green and indigo. Use a dry brush for smaller marks at the top of the trees. Add touches of cadmium lemon here and there.

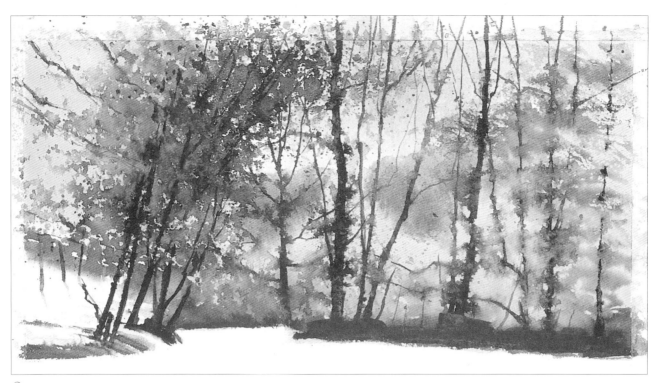

9 Spatter water across the wooded area, then, still using the dark mix (phthalo green and indigo) brush tree trunks through the spattered water. Spatter the dark parts of the foliage. Darken the far bank of the stream. Add touches of light red to the mix for the branches in the sunlit area at the left-hand side of the painting.

10 Add two thin lines of masking fluid on the far distant stretch of water. Wet all the water area, lay in vertical strokes of watercolour medium sparingly on to this area, then lay in a wash of cadmium lemon as the base coat for the reflections of the foliage.

11 Add neat cerulean blue to the distant stretch of water. Use a mix of Payne's gray and phthalo green to add dark reflections of tree trunks and the dark parts of foliage. While this is still wet, soften the edges of all shapes with cadmium lemon. Add more touches of neat phthalo green, to define brighter reflections, and burnt sienna.

12 Mix a brown wash from burnt sienna, ultramarine blue and new gamboge, then lay in the areas of dark reflections on the water, darkening the mix as you work downwards.

13 Add more burnt sienna and some cadmium lemon to the mix and blend this into the brown in the middle distance. Soften the edges that meet the distant reflections. Lay in horizontal stripes of Payne's gray, and allow these to blend into the background colour.

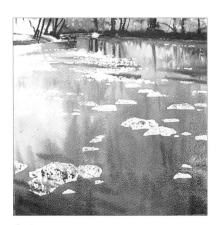

14 Working wet into wet, add random strokes of ultramarine blue to the brown at the bottom of the water to define the very dark reflections.

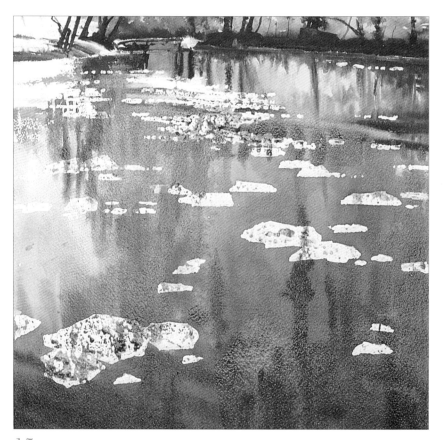

15 Blend touches of cadmium lemon to the edges of the brown reflections at the middle and left-hand side of the water, then use mixes of phthalo green and Payne's gray to paint in the very dark reflections of trees in the background. Note the effect of the wax resist applied in step 3. Add burnt umber to the palette, then paint in vertical strokes in middle distant stretch of water. Soften the edges of the browns with clean water and touches of cadmium lemon.

16 Mix ultramarine blue and burnt umber to make a very dark brown, then add patches of shadow at the bottom-left and bottom-right. Make smaller strokes with this colour across the whole stretch of water. Add cadmium lemon to the mix and blend paler tones into the darks. Use Payne's gray to introduce more dark shadows in the middle distance.

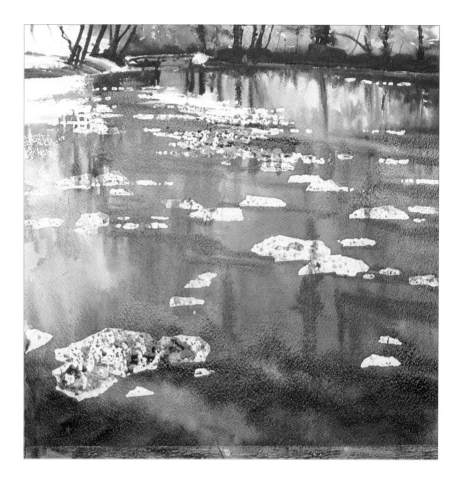

17 Working wet in wet, strengthen any weak tones with a mix of burnt sienna and phthalo green. Add a few horizontal streaks of Payne's gray as ripples and shadows under the masked-out rocks. Leave to dry, allowing all the colours to soften and blend together.

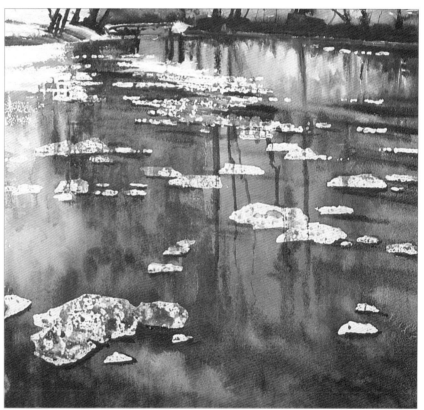

18 Use the dark mix of phthalo green and indigo, wet on dry, to redefine the vertical shadows of tree trunks and to extend them down into the foreground area. Use the same mix to emphasize the shadows below all the dry rocks. Leave to dry.

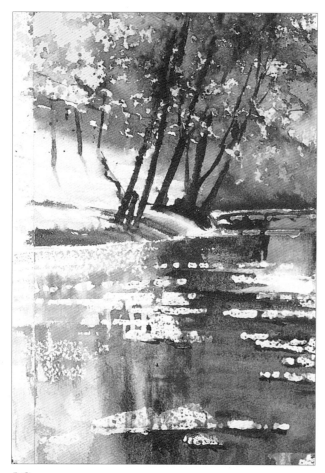

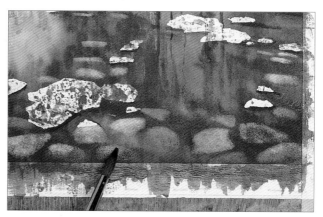

20 Wet small areas of the water with clean water . . .

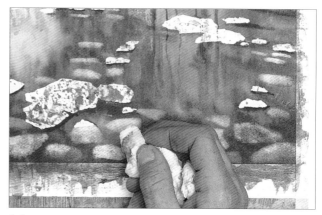

19 Lay a weak wash of cadmium lemon across the land part of the remaining white space, and cerulean blue over the water part. Add touches of green as faint reflections.

21 . . . then use clean pieces of paper towel to lift off the colour in the wetted areas.

22 When all the submerged rocks have been lifted out, allow the paper to dry out completely then remove all the masking fluid.

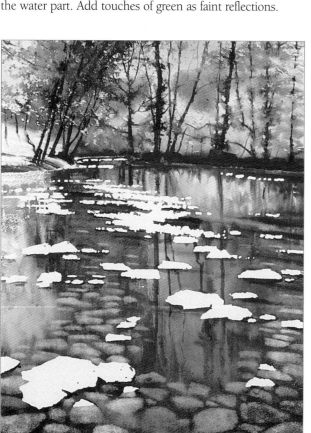

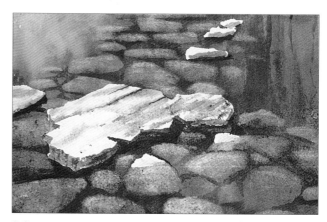

23 Mix a greeny-grey from manganese blue and burnt sienna, then paint in some texture on the dry parts of the foreground rocks. This colour mix gives very good granulation. Darken the mix slightly for the shadows on the top and sides of each rock.

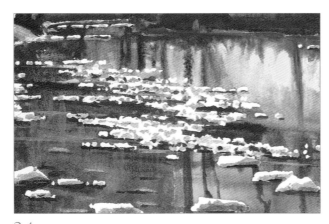

24 Use the same mix of colours to add shape and form to the smaller rocks in the middle distance.

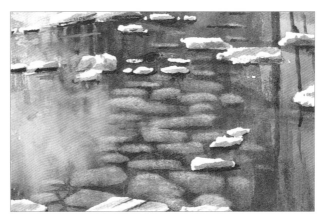

25 Finally, use a weak mix of Payne's gray and burnt sienna to paint a latticework of shadows between the submerged rocks.

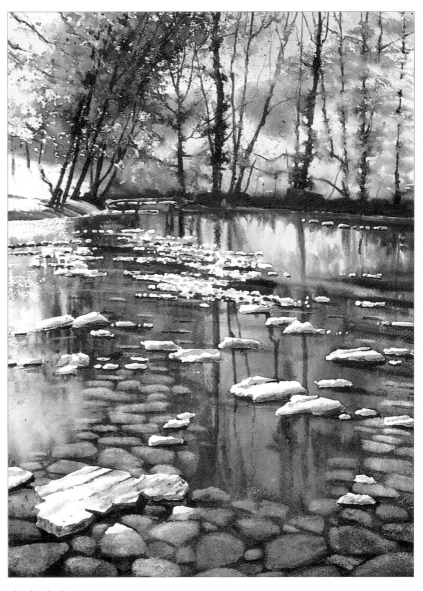

The finished painting

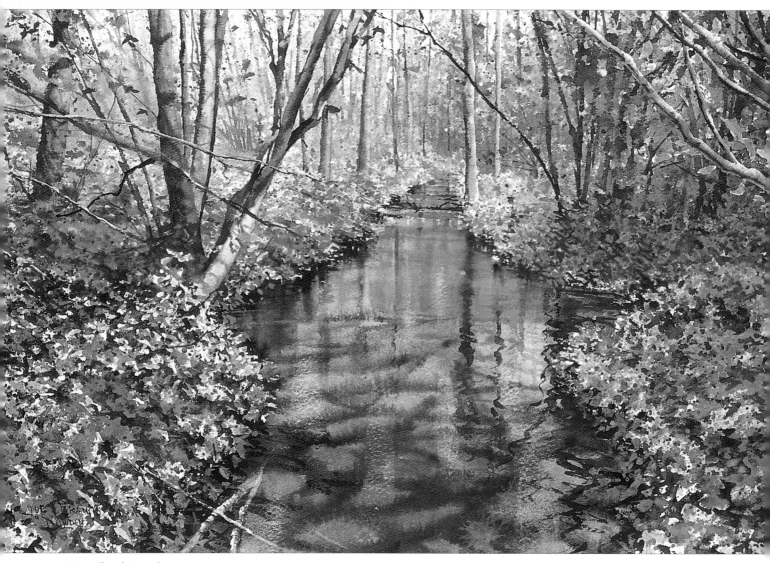

Woodland Brook

Size: 430 x 285mm (17 x 11¼in)

I added gum arabic sparingly to a wash of
clean water on the river before painting the
reflections. Gum arabic stabilises the
reflections, allowing them to blur without
spreading too far and being absorbed into
the painting. Then, while the water was
still wet, I painted the tracery of branch
shadows in a diagonal pattern, flattening
them out rapidly with distance. The
diagonal shapes run counter to the vertical
reflections, but look wet because they are
blurred. The flattened look of the tracery
of shapes is strongly suggestive of the effect
of refraction, which seems to flatten and
squash underwater shapes. The faint
vertical lights on the surface depict the
reflected hazy skylight coming through the
wooded canopy. These marks read as wet,
and are created by gently lifting out colour
with vertical strokes of a damp sable
brush, and leaving it to dry without
dabbing with tissue.

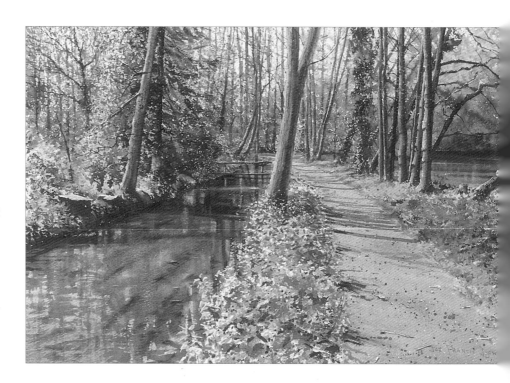

80

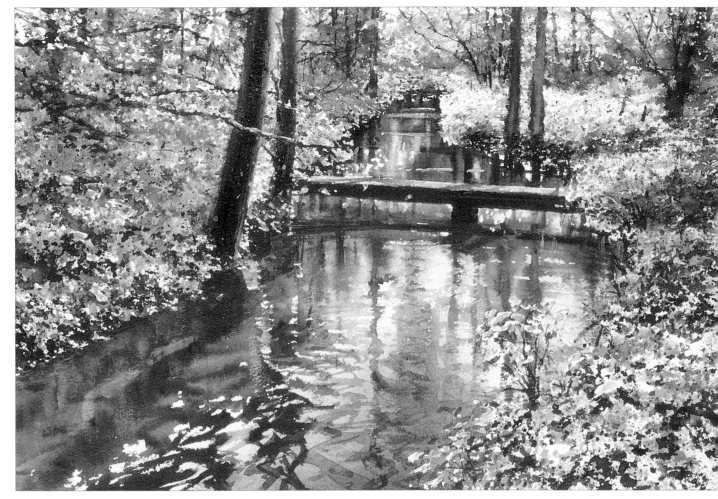

Rippling Bourne

Size: 510 x 325mm (20 x 13in)

Water twists and bends the light that is reflected on its surface, but it is different with light arriving from the river bed. Having been bent by refraction, it stays relatively stable – it shimmers a little, but hardly enough to paint. Compare the area of shadow at the left-hand side of the river with the sunlit areas. The shadowed area acts as a window to the bed of the river. Through this can be seen long shadows, which although blurred, are quite straight compared with the wildly fluctuating ripples in the middle of the river. The reflection colours are burnt sienna, cadmium lemon, Payne's gray, and phthalo green. Notice how the vertical scuff marks made with a damp brush on top of the water make it look like there is a glassy surface.

Opposite
Jim and Shirley's Walk

Size: 430 x 280mm (17 x 11in)

Many of the little leaves at the edge of the river bank were masked with a colour shaper before starting to paint the river. When the initial sky-reflection wash on the river was dry, a large area of the brown reflection was rapidly brushed in with a wet wash of burnt sienna and cobalt blue. A few vertical lights of the underlying sky wash were left to depict the gaps between trees. Cadmium lemon and phthalo green were added to the rich brown wash and then dark shadows on the river bed were painted across. As water travels down a shallow stream like this one, it drags mud and debris along the bottom, and this is sometimes visible as textured streaks. Painting these streaks strongly suggest the river bed seen through the surface of the water. Some more cadmium lemon was run in vertically, then a few vertical scuff marks were made with a damp brush. These marks help make the surface of the water appear transparent – like a thin veil that can be seen through.

Richness and depth

How do you define the qualities of water when it is subject to so many moods and changes? Here, in this final demonstration, I have tried to capture the essence of water, bringing together most of the visual qualities discussed so far.

The river is framed like a jewel by the arch of the bridge. You can see the gentle up and down motion of the water and the way texture is dragged out vertically by the tiny ripples in the distance. A deeper swell moves along the surface of the river in the foreground, fragmenting the reflections at their tips and bending them in a rhythmical motion, projecting a sense of movement.

It is possible to paint a shining wet river on dry paper and to give it a sense of movement, even though it is static. By painting common visual effects, triggers of recognition can be activated in the mind of the observer. Water really can be made to look wet.

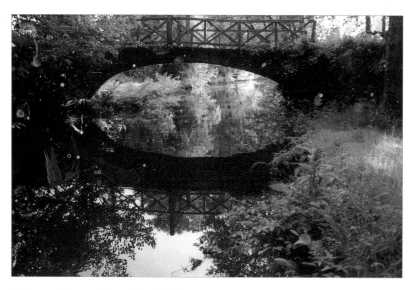

Reference photograph used for this demonstration.

Use plenty of water to make a river look wet.

82

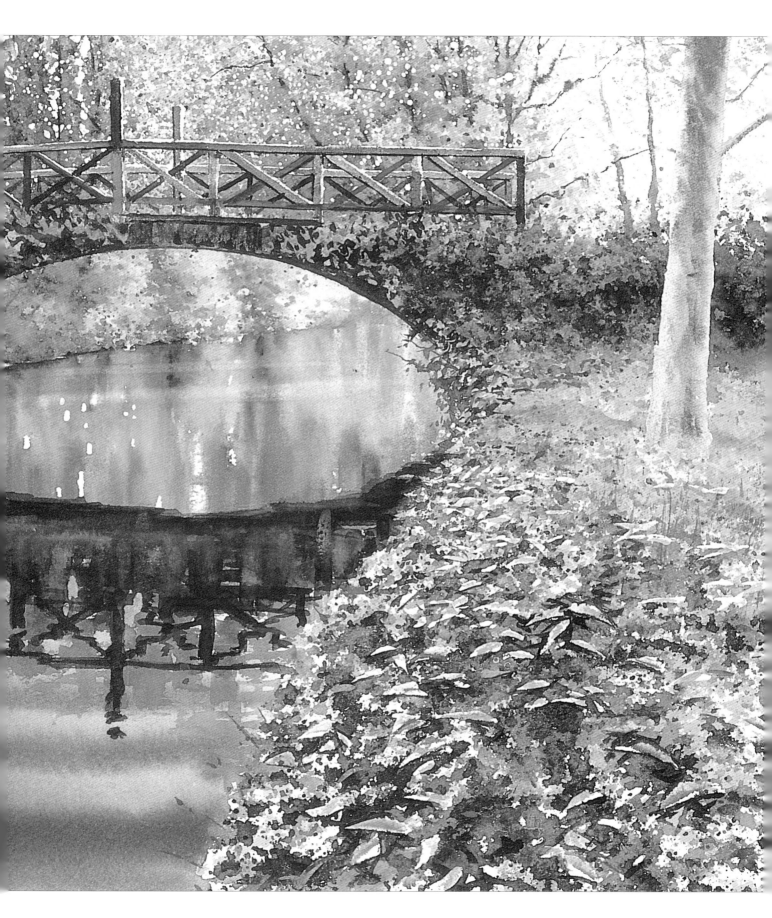

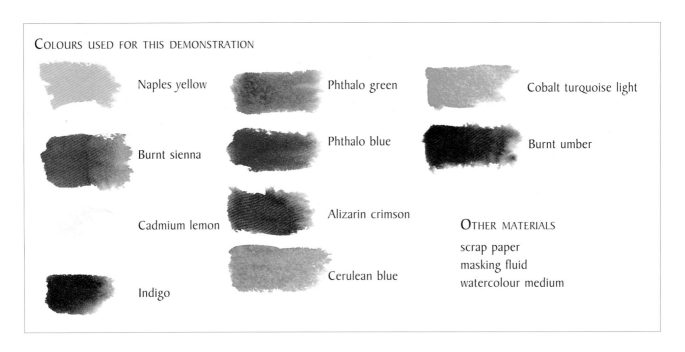

COLOURS USED FOR THIS DEMONSTRATION

Naples yellow

Phthalo green

Cobalt turquoise light

Burnt sienna

Phthalo blue

Burnt umber

Cadmium lemon

Alizarin crimson

OTHER MATERIALS

scrap paper
masking fluid
watercolour medium

Cerulean blue

Indigo

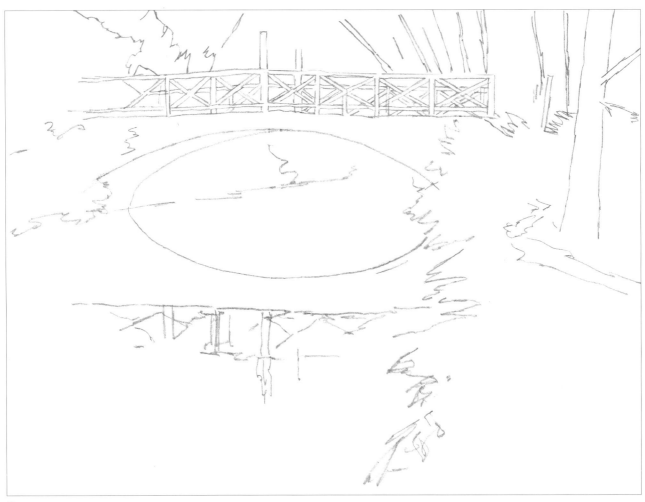

1 Referring to pages 24–25 and the reference photograph on page 82, draw a
pencil sketch of the composition then transfer it on to watercolour paper.

2 Use masking fluid to block out all highlights as shown below. Use a shaper brush to draw the lighter parts of the bridge and some vertical highlights in the water. Use the shaper brush and then the drawing pen to create fine-pointed leaf shapes in the foreground. Use an old toothbrush to spatter small speckled highlights in the area of foliage behind the bridge. Use an old paint brush, with a blob of dry masking fluid on the bristles, to dab in rough patches of light areas between the background trees.

3 Using the spattering technique described on page 50 with a No. 8 round brush and cadmium lemon, build up a layer of small leaves at the top of the painting. Use a No. 16 brush to create larger speckles in the foreground. Block in the areas of foliage at the left- and right-hand sides of the bridge and the brick part of the bridge itself. Weaken the mix then block in the foliage that is visible through the bridge. Mask out the large tree trunk at the left-hand side and a couple of gaps between the trees at top centre left. Leave to dry.

4 Cut a paper mask for the shape of the arch of the bridge and mask this area and all the water area. Start to build up the texture of the foliage with spattered glazes. Begin with cobalt turquoise light . . .

5 . . . then spatter glazes of different greens made with cerulean blue, cobalt turquoise light and cadmium lemon. Remove the scrap paper masks, then leave to dry.

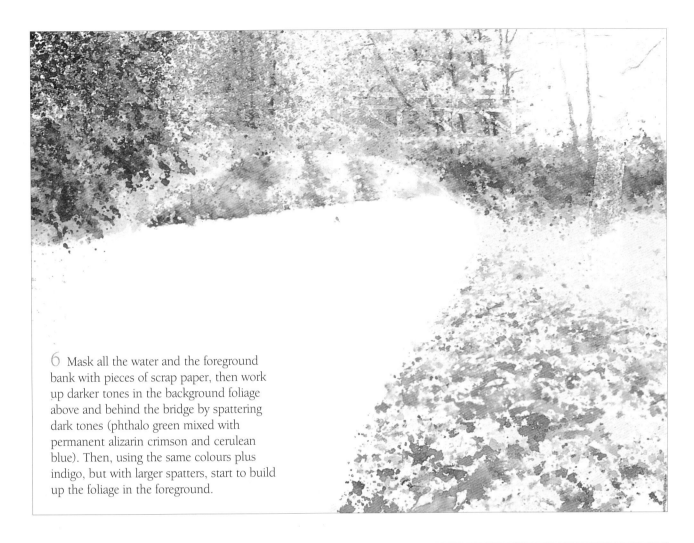

6 Mask all the water and the foreground bank with pieces of scrap paper, then work up darker tones in the background foliage above and behind the bridge by spattering dark tones (phthalo green mixed with permanent alizarin crimson and cerulean blue). Then, using the same colours plus indigo, but with larger spatters, start to build up the foliage in the foreground.

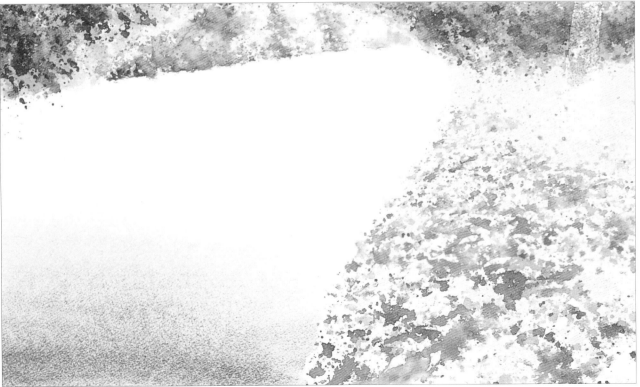

7 Wet all of the water area, then, using a wash of phthalo blue with a touch of indigo, lay in the water. Weaken the colour as you work up towards the bridge.

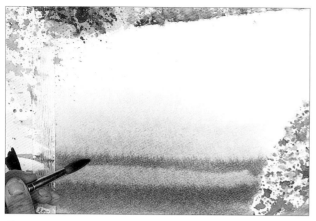

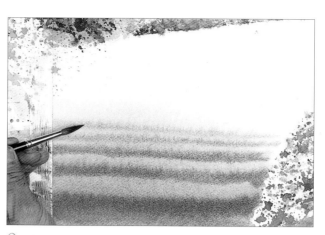

8 Mix a wash of indigo and phthalo blue, then, using a No. 16 round brush, lay in two horizontal strokes across the bottom of the water.

9 Change to a No. 8 brush, then lay in more horizontal strokes, making these narrower as you work upwards.

10 Soften the edges of the narrow streaks with clear water.

11 Then, using small, random, crosscross strokes, link the water to the edge of the foreground foliage.

12 Add more detail to the foreground foliage by spattering water followed by a mix of indigo and phthalo green – make large marks at the bottom of this area and smaller ones as you work backwards.

13 While the spattered paint is still wet use the No. 8 round brush to draw some of the spatters together to create larger, more defined shapes.

14 Work up the right-hand middle distance area of foliage, by spattering in darks from the palette.

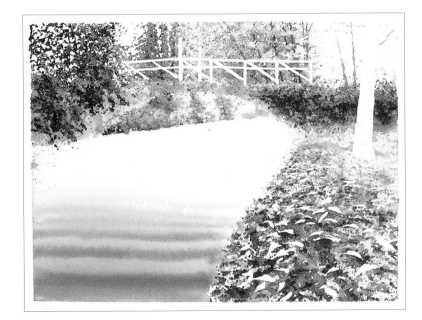

15 Remove the masking tape from round the edges of the painting, then, when the paint is completely dry, peel off all the masking fluid except those parts in the water.

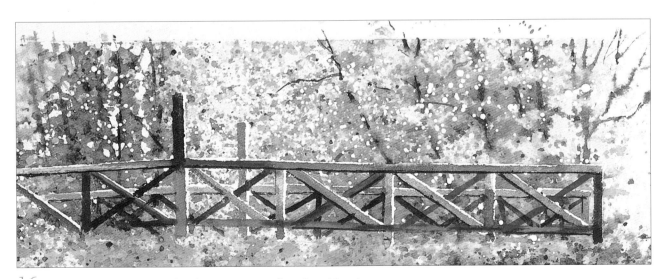

16 Replace the masking tape border. Use mixes of cerulean blue, burnt umber and phthalo green and a No. 2 round brush to block in the wooden railings, leaving white highlights along the top edges of each strut. Add a touch of indigo to the mix for the darker parts and the shadows.

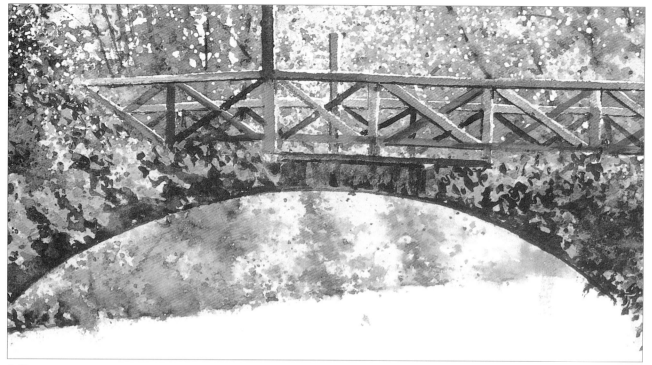

17 Mask the curve of the arch and the water below, spatter clean water over the front face of the bridge then, using burnt umber mixed with a touch of the dark on the palette and a No. 3 round brush, start to define the bridge structure. Add more indigo to the mix for those parts in the shadow of the foliage – use negative painting round individual leaf shapes. Remove the masks and leave to dry.

18 Build up shape and form on the large tree trunk. Block it in with a mix of Naples yellow and cadmium lemon, then, while this is still wet, add touches of cerulean blue, burnt umber and indigo. Soften all edges and blend the colours into each other.

19 Use cadmium lemon, then cobalt turquoise light and indigo to paint in the remaining leaves in the foreground leaving small white highlights.

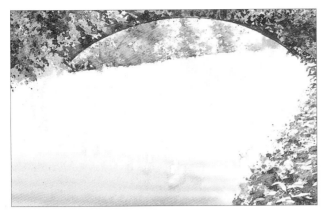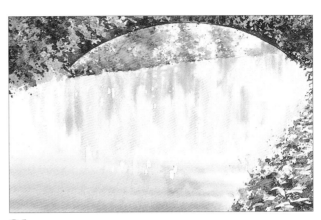

20 Wet the reflection areas of the foliage and bridge, but leave a few vertical lines dry. Overpaint some parts of the wetted area with watercolour medium, then lay in rough vertical streaks of cadmium lemon.

21 While these yellow marks are still wet, lay in a patch of cobalt turquoise light on the distant bank under the bridge then pull down a few short vertical streaks. Working quickly, lay in rough vertical streaks of burnt sienna, cadmium lemon and phthalo green between the cadmium lemon ones. Allow the colours to blend together.

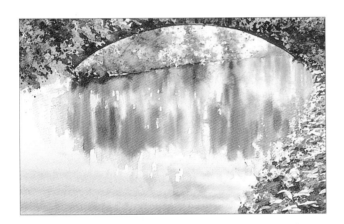

22 Mix indigo with touches of phthalo green, then, still working wet into wet, add dark green reflections. Mingle streaks of cadmium lemon and burnt sienna between the darks. If necessary, reinstate the cobalt turquoise light marks. Soften any hard edges that start to form. Define the edge of the far bank of the river with indigo, then pull this colour down into the reflections. Leave to dry.

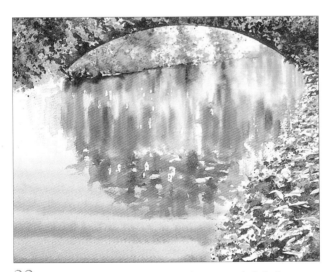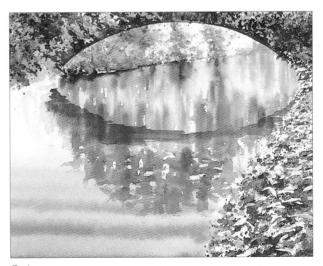

23 Now, working wet on dry, with mixes of phthalo green, cadmium lemon and burnt sienna, start to work the rippled reflections in the foreground water. Add indigo to the mix and lay in some darks among the rippled reflections, then leave to dry.

24 Use the original tracing to redefine the shape of the bridge's reflection. Mix a dark from burnt sienna and indigo then, using a series of roughly horizontal strokes, block in the reflection of the curve of the arch. Soften the bottom edge with water.

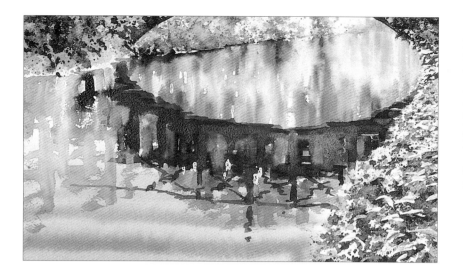

25 Using the dark tones on the palette, continue to develop the reflection of the bridge. Add some vertical strokes of cadmium lemon overpainted with burnt sienna. Note that the reflection of the bridge is larger than the bridge itself as it includes the underside of the arch. Use cadmium lemon to lay in a base coat of the reflection of the foliage at the left-hand side of the painting.

26 Develop the reflections at the left-hand side, using vertical and horizontal strokes and the colours of the foliage above. Make the brush strokes larger and harder-edged as you work down the painting.

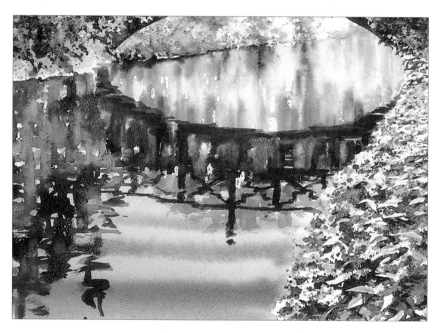

27 Continue to develop all the reflections using both dark and light tones from the palette.

92

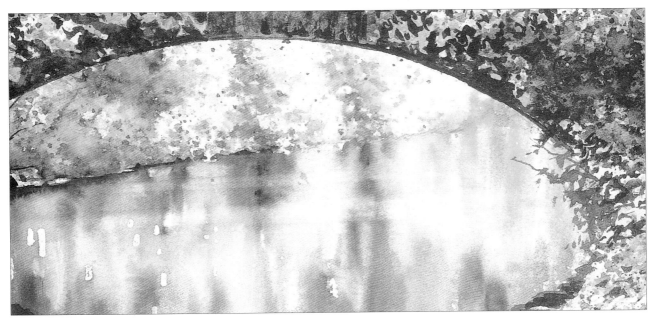

28 Use a bristle brush and clean water to scrub out two horizontal lines. Dab off water (and colour) to leave pale horizontal streaks.

29 Remove the masking fluid from the water then use the colours in the palette to block in some of these.

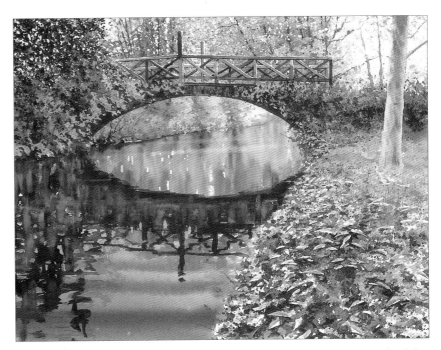

The finished painting. Having stood back and looked at the whole composition I decided to add touches of cadmium lemon in the right-hand area of the sky, to redefine some of the foreground leaf shapes and to add the indication of grassy spikes in the middle distance.

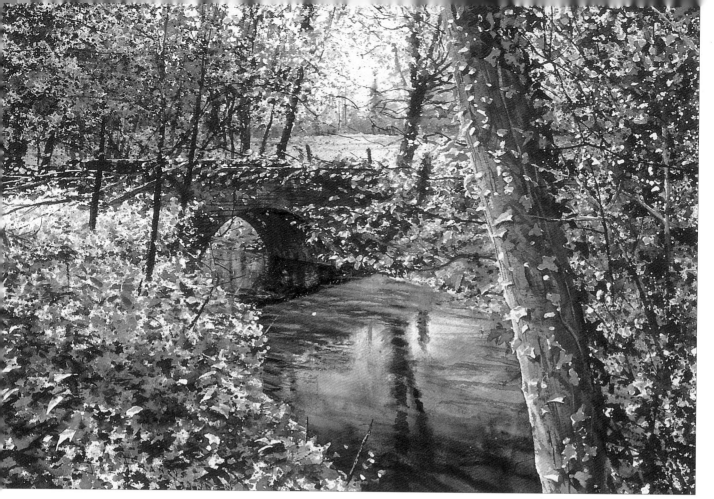

Old Masonry Bridge

Size: 355 x 240mm (14 x 9½in)

Sharp-focus detail around this river puts it in a convincing setting. Many of the leaves were individually masked before the foliage texture was spattered on. A rich violet of phthalo blue and alizarin crimson was used for the sky reflection in the water. When this was dry, a warm brown wash, mixed from burnt sienna, cadmium lemon and Naples yellow was glazed on top, to which touches of phthalo green were added. The bridge reflection forms a large 'window' through which the river bottom colour can be seen. Here a pattern of darks was dragged through the wet wash using Payne's gray. The arch is only hinted at, and painted wet in wet, and the reflection below it is in shadow from the bridge, with a pronounced edge to the shadow running across the river. Reflections and details are just visible through the arch. A high concentration of colour was used, watercolour is well suited to intense images, it can rival any other medium in strength. Foliage colours are cadmium lemon, phthalo green, and burnt sienna or burnt umber mixed, with a mixture of Payne's gray and phthalo green for the darks.

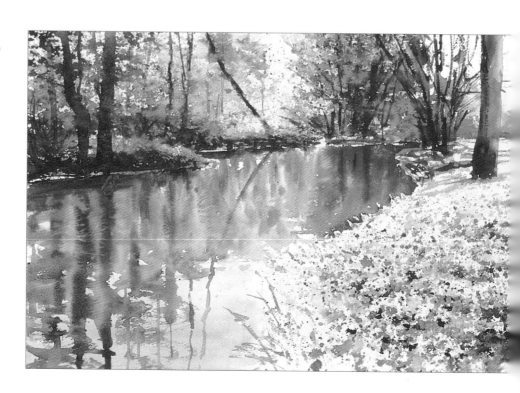

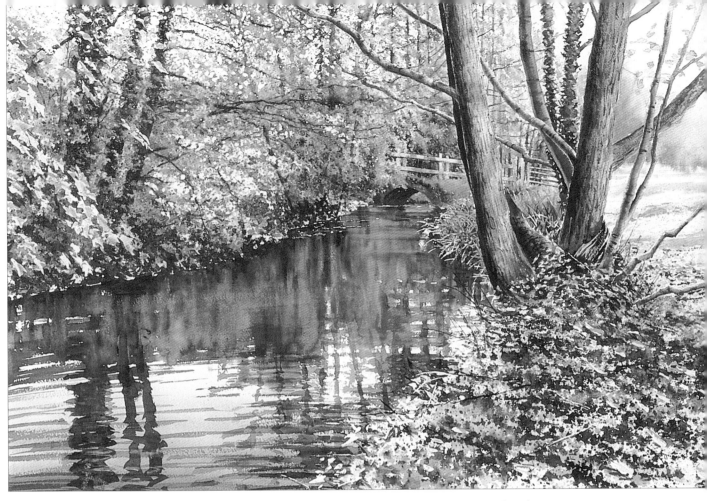

Opposite
Parkland River

Size: 430 x 280mm (17 x 11in)

This scene was painted facing a low late-afternoon sun, and the strong yellows from backlit foliage provide a stark contrast with the deep shadows. Scrap paper stencils were used to mask the ragged river-bank, then the foliage was spattered vigorously using a wet spattered colour into spattered water technique. The dark trunks, brushed through the woodland while the spatter was still wet, alternate between sharp focus and diffused patterns as they pass through wet and dry patches on the paper. The water was painted in two washes. First, an upside-down sky wash of phthalo blue, quinacridone red, and indigo was applied. When this was dry, a very wet and loose wash of lots of colours – cobalt turquoise light, cadmium lemon, burnt sienna, phthalo green, Payne's gray – were added separately into the top half of the river and brushed down vertically. The tree was painted by wetting the trunk and adding colour to one side, then repeating the process later with a darker tone. Long tree reflections were dragged out of the bottom of this wash and painted wet on the dry paper.

Weston Reach

Size: 660 x 510mm (26 x 20in)

I used so much water in this painting that I almost poured this river rather than painted it. Water can be painted with water. In some ways it behaves in the same way on the paper as in the river. A river can be painted wet in wet, or the wet colour can be brushed onto dry paper. Colour can be mixed in the palette, or on the paper. In this scene many colours were brushed into the water separately and allowed to blend. Genuine cotton rag watercolour paper, 300gsm (140lb) or heavier, will sustain the large quantities of wet colour required. The foreground tree on the right was masked so that paint could be applied loosely all around it. Its form helped make this composition, try and imagine how featureless the painting would be without it.

Index

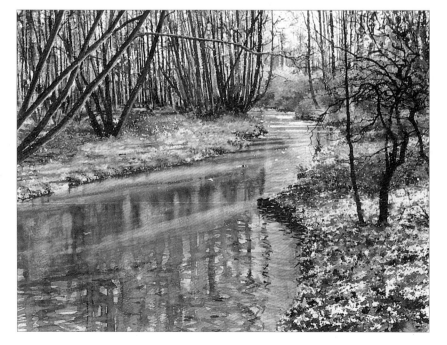

Wonham Way

Size: 405 x 305mm (16 x 12in)

In this winter scene of a muddy, fast-flowing river, the trees are a mass of lines worked with the point of a brush. Some long sky holes – vertical gaps between the trees – were painted roughly with an old brush. Nearby trees were masked along one edge to depict the sunshine glancing off them and a streak of light was lifted off the water nearby. The streaks further back were painted by saving the underlying cadmium lemon, and adding a little water and gum arabic along them to keep surrounding colour away.